anic spiced onion.
osmos.
r-changing cast.
chaos.
everyone.
ss opportunity.
nd colour.
d busy.
peed of light.
d fast-moving.
ess.
he taking.
he making.
open, but not easy.
ractions.
lex.
takes you down.
dapt to.

City Shapers
London

City Shapers
London

The creative people
changing the city

Senta Slingerland
Photography James Merrell

LANNOO

005 Content
006 Foreword

240 Colophon

008 Liv Little
018 Ryan Chetiyawardana
 aka Mr Lyan
028 Ibrahim Kamara
036 Andrea Román
048 Tom Broughton
056 Anna Murray and
 Grace Winteringham
064 Julius Ibrahim
072 Fabien Riggall
082 Asif Khan
094 Honey Spencer
102 Fernando Laposse
112 Josh Cole
122 Martin Usborne
 and Ann Waldvogel
130 Petra Barran
140 Catherine Borowski
 and Lee Baker
150 Lewin Chalkley,
 Matt Harper and
 Sam Humpheson
158 Charlie May
168 Maxime Plescia-Büchi
178 Stefanie Posavec
186 Jeremy Chan and
 Iré Hassan-Odukale
194 Morag Myerscough
204 Rosaline Shahnavaz
214 Mark Maciver
222 Vicky Jones
230 Fred Higginson,
 Rose Stallard and
 Kate Higginson

"A city isn't so unlike a person. They both have the marks to show they have many stories to tell. They see many faces. They tear things down and make new again."

—Rasmenia Massoud, author of *Broken Abroad*

A city is shaped by the people who live in it. It's they who create a city's culture and give it its unique flavour, moulded by their needs, interactions, habits and ambitions.

A city is nothing without its communities of people who work every day to make the city more liveable, more inclusive and, essentially, more interesting. A city isn't just a reflection of the tastes of a distinct few, at the top of its proverbial pyramid, but rather a mirror of all its inhabitants, their distinct backgrounds, interests and skills. In the words of author Jane Jacobs, "cities have the capability of providing something for everybody, only because, and only when, they are created by everybody."

The ever-evolving shaping of a city is born out of necessity and desire: the constant need for change to accommodate new ideas, technologies and people, and the thirst for making things better. Without the people who are willing to put their all on the line, without the bravery to reinvent what's already there and think up completely new things, a city is just a collection of buildings, parks and rivers, with roads in between that connect them.

City Shapers London is a discovery of the people who are shaping one of the world's most dynamic and taste-making cities in the world. The people in this book are the ones who are imaginative enough to be turning London into an inspiring playground for others to play, experiment and relish in. Their innovations and modi operandi are changing how Londoners drink, eat, dress, work, enjoy art and are entertained.

These City Shapers are not an exclusive list of people, of course. Rather, they are a sample of the incredible and generous minds that make this city what it is and what makes other cities around the world look to it. In choosing these creatives and entrepreneurs, one criterion was key: to pick people with a true vision of how to do things differently, to change things for the better. This book celebrates those who had the guts and vision to try something new, in the belief that the city would be better for it.

London is hailed by many as one of the most diverse and inclusive cities in the world. While this is something to be proud of, it's clear that a lot work is still ahead to ensure everyone has an equal place and voice in this sprawling metropolis. But things are changing, and people of all ages, colours, gender or sexual identities, and belief systems are increasingly carving out places that reflect them.

This book celebrates them: the game changers, the change makers, the boundary breakers, the brave, the crazy … those who make London one the most creative cities in the world.

Liv Little

gal-dem

Bringing under-represented voices to mainstream media

For the past three years, Liv Little has been introducing a new voice to mainstream journalism. With *gal-dem*, the online and printed magazine created by women and non-binary people of colour, Liv and her expansive network of contributors add an often underrepresented point of view to the world of publishing, discussing anything from politics, finance, business and mental health to dating, family, entertainment and fashion.

"It's not just about who you see presented in media; it's about who is in control of who you see."

Their content spans topics from 'Navigating dating as a Muslim gal: lies, alibis and imposter syndrome', 'Porn and the racial pay gap' and 'Afro hair: why all the fuss?', to 'A prince visits Africa: white conservation, colonial conversations', an article that followed on the heels of the Duke of Wellington's (aka Prince William's) visit to Tanzania. The *gal-dem* team has interviewed the likes of media mogul Oprah, actor Lupita Nyong'o and Reni Eddo-Lodge, the author of *Why I'm No Longer Talking To White People About Race*, attracting the attention of readers far beyond UK borders. Today, 50% of its reader base is in the UK, 23% in the US (where *gal-dem* organises regular events) as well as in Canada, Australia, India and France.

"The concept of *gal-dem* isn't mindblowing. The difference between me and everyone else who has had this idea is that I found people who just went 'Yeah, let's go'." While studying politics and sociology at Bristol University, Liv, who is of mixed Jamaican and Guyanese background, was desperate to connect with other women of colour. "I didn't see anyone who looked like me there and definitely didn't see different types of people reflected in the curriculum." She started posting on messaging boards and Facebook to try to connect with others who felt similarly. Her efforts led to her connecting with the like-minded souls she so needed, including Leyla Reynolds. They met in a feminism class and bonded over a joint frustration with the fact that the class was taught by a white man. Another was Antonia Odunlami, now a founding member of *gal-dem*. The three of them started prototyping what a *gal-dem* site could look like. "The name came easily—it's what I've always called my group of girls. Initially, we just shared existing content that resonated with us. The original content came a bit later."

At one of *gal-dem*'s first-ever meetups, Liv met Charlie Brinkhurst-Cuff, now the magazine's deputy editor as well as a regular contributor to *The Guardian* and author of *Mother Country: Real Stories of the Windrush Children*, a book about the generation of people who came over to Britain from the Caribbean after WWII. "We all have second and third jobs here," Liv explains. She herself wears different hats: as executive producer for BBC's factual commissioning team, she works with the digital team to create original, factual, digital content for younger audiences, and she is also a contributing editor for *Elle*, *The Guardian* and *Wonderland*.

Once a year, *gal-dem* publishes its printed magazine. The first issue came out in 2016 and focused on the notion of 'galhood' and growing up. The second talked about home as identity and the third delved into the theme of secrets. For the latter, *gal-dem* worked exclusively with

beauty brand Glossier to produce an eight-page advertising spread featuring five black women with luscious afros, accompanied by the specially created tagline 'That's why her hair is so big, it's full of secrets.' At £10 per issue, the physical magazine is affordable enough to reach its desired audience, but expensive enough to feel like a collectible. A relic of a moment in time.

gal-dem has collected a strew of accolades, including the Comment Awards' Site of the Year, an Honour for Media from the *Gay Times*, and a Georgina Henry Award for the recognition and promotion of female talent in journalism. "That was a special one for us, because it's basically the BAFTAs of the press world. Awards don't mean too much to us personally, but they are important for how others perceive you."

In August 2018, gal-dem reached a new audience with the takeover of *The Guardian* newspaper's weekend magazine. The gal-dem team generated ideas for the articles and commissioned writers, illustrators, photographers and stylists. The issue was exclusively created by—and only featured—women and non-binary people of colour, with actor Michaela Coel gracing the cover (shot by Rosaline Shahnavaz, see p. 209) and contributions by vlogger Dina Tokio, author Chidera Eggerue and politician Diana Abbott. It received a huge response from social media, including tweeted photos from the 'Hamilton the Musical' cast of themselves reading the issue in their dressing rooms. It was a great success for *The Guardian*, resulting in more requests for back copies than they had seen in years and the first time they sold standalone copies. The magazine sold 7,000 more issues that weekend than on any other given weekend. "If that doesn't prove that there's money to be made from giving voice to people of colour, I don't know what does. When people see themselves represented, they invest," Liv points out.

The collaboration between the two publications started as a conversation between its deputy editors: Charlie from *gal-dem* and Ruth Lewy from the newspaper. It was six months in the making. In an article on *The Guardian* website, Melissa Denes, the editor of *Guardian Weekend*

"There's money to be made from giving voice to people of colour. When people see themselves represented, they invest."

Magazine, describes what the newspaper learned from the experience: "We could do much better when it comes to commissioning writers and creatives of colour—not just because we want to better reflect our readership and the people that don't read us yet, to produce a richer magazine, but because there is so much talent out there. This was a strong reminder that it's a megaphone and it matters who you give it to."

These days, aside from producing the online and printed magazine, gal-dem's business model allows the team to tap into other skill sets: providing marketing insight and content to brands such as Nike and Ace&Tate, who are keen to reach a different, younger or more diverse audience, and programming events at established cultural venues, including The British Film Institute, Barbican, Victoria&Albert Museum and the Tate.

To coincide with Penguin Random House's release of Michelle Obama's book *Becoming* in late 2018, gal-dem launched a pop-up bookstore with books written exclusively by women and non-binary people of colour. The temporary structure also hosted a variety of events, including a panel discussion on black motherhood, workshops on mental health and confidence, and an exhibition of photographs from Obama's life. The proceeds were donated to the Black Cultural Archives, the UK's only repository of black history.

Editors Letter
LIV LITTLE & CHARLIE BRINKHURST-CUFF

Secrets can be fun, necessary, toxic or a delicious combination. We wanted to use this special issue, featuring our two incredible cover stars, Raveena and Nao, to explore every meaning of the word. Each year, we tackle a theme which feels pertinent to the time that we are living in and as women and non-binary people of colour living in a world which is increasingly fractured, it felt timely to explore some of the things we want to say but don't always feel able to. In 2018, everything for gal-dem hit roller coaster speed. Less than three years after launching we've taken over the Guardian Weekend magazine, started working on a book project with Walker and showcased a Windrush Women exhibition at City Hall. At times it feels hard to keep up, but in the midst of it all, we don't want to keep quiet about our achievements. 2018 has been a year where women and non-binary people of colour have shaken the world. For this print issue, gal-dem's editors have done an incredible job of curating personal content that speaks to our guilty pleasures, the stories of immigration our parents and grandparents don't always share and the anonymous letters that we have struggled to send or say aloud. Our features include the secret lives of beekeepers, repair work post-Grenfell, a look into the perceived sexuality of women in the music industry, the hidden histories of stolen art in UK galleries (inspired by *Black Panther*), and interviews with Fatima, Paloma Elsesser and Travis Alabanza.

We really hope that you enjoy this third iteration of our print and find a little something in it which speaks to you directly. A huge thank you to Glossier, who are the sole advertisers within this issue. It has been a pleasure working with you to produce an Afrocentric editorial based on our favourite *Mean Girls* quote: "That's why her hair is so big, it's full of secrets".

Lots of love,

Liv x Charlie B-C

"London is rich in diversity but poor in diversity of thought."

For Tate Modern's Late nights with UNIQLO, *gal-dem* programmed the music and visuals, focusing on black suffragette Ida B. Wells. In its 2017 takeover of the V&A, *gal-dem* commissioned 100 women of colour to produce elements and activities for the museum's huge space, ranging from Bollywood dance workshops and a night of Caribbean cinema to anime sketching classes.

"It was quite profound: we knew that what we were doing was resonating with people because of the messages we were getting and the amount of people reading our online content. But when you see 5,000 people queuing around the block for the V&A, it really brings it home. These were people who might have never felt comfortable coming to the museum before, supporting artists who had previously been absent from these spaces."

This is, in essence, what Liv is doing: giving space to people who have previously been denied, ignored, left out or repelled from, mainstream spaces. For example, even though over 30% of Londoners are people of colour, a Reuters study from 2016 painted a disheartening picture of UK newsrooms, finding them to be 94% white. It found that only 2.5% of British journalists are Asian and 0.2% are black.

"It's not just about who you see presented in media; it's about who is in control of who you see. Equally, it's not just about hiring more diverse talent; it's also about how to retain them. In TV there are certain rules about diversity needed in the makeup of the crews, and journalism could do with similar guidelines. Because despite the fact that London is rich in diversity, it's poor in diversity of thought."

How to get stuff done in London:
You need to surround yourself with people who understand what you need done. You need a community.

What makes a Londoner?
We're all a little neurotic and we're always in a rush.

London in a nutshell:
London is changing all the time.

Ryan Chetiyawardana aka Mr Lyan

Lyaness, Cub

Revolutionising our drinking culture

Ryan Chetiyawardana, also known as Mr Lyan, has been pioneering a revolution in bartending for years. Frustrated by the set ways in which bartenders around the world work, he has launched drinking and eating establishments around London that prove that there are other ways of doing things, winning him numerous awards along the way, including Bartender and Innovator of the Year and even Personality of the Decade.

"Sustainability and luxury isn't a contradiction in terms."

His first bar, White Lyan, opened in 2013 as the first cocktail bar in the world not to use perishables, fruits or ice. All the drinks were premade in a professional kitchen, using only Lyan's own-brand spirits. Its menu, which served delights like the Sandman Sour—made with Mr Lyan Bourbon, blood orange, sand verbena and zip—and the Wu Wu Mojito—a blend of Mr Lyan Rum, distilled mint, peach and grass soda—questioned the worldwide cocktail convention of 'two parts spirit, one part citrus, half a part sweetener' by experimenting with new ingredients, new flavours and new textures. "We took apart every drink and could justify every ingredient in it and say why it's there." They used alternatives to the acidulants, bittering agents and sweeteners everyone else was using and in the process reduced an enormous amount of waste. "There's a fetishism around the drinks industry so people feel they can't change that. But even with something that's really ancient, you need to innovate. The world evolves and so ideas need to evolve as well."

One of the more interesting ingredients he uses is ambergris, a sperm whale's fur ball. "It's hard to make it sound attractive because it's essentially the undigested beaks of the giant squid that whales eat, coated in a secretion and coughed up. But it's one of the most amazing ingredients I've ever worked with." The ambergris eventually washes up on shore and becomes a highly sought-after substance for perfumers, with a piece the size of a thumbnail retailing at £200. "We get a bunch of stoners in New Zealand to search for them. Part of the sales goes to a programme that protects the whales because without the whales, there's no ambergris."

Sustainability has increasingly become a huge driver for Mr Lyan. "When I initially started talking about sustainability, it didn't resonate at all. I wanted to explain that sustainability and luxury isn't a contradiction in terms. A decade on, and it's all people are talking about." In the early days of White Lyan, the bar only produced enough waste to fill a domestic bin. There were no napkins, no straws, and only refillable bottles. There was no fruit wastage and no discarded plastic ice bags.

But the bar was more than an exercise in sustainability. It was also about offering the best possible experience for the customer. "The skill of a bartender to me is making a really fast psychological assessment of a person and finding a way to direct that mood. A cocktail can be comfort, escapism or joy, and I wanted to be that switch for people." Since it only took Ryan 10 seconds to serve a drink, he could do just that. Customers were not required to listen to the whole backstory of a cocktail, or even know what they liked. It took all the pressure of going to a cocktail bar off. "I hate being lectured to in bars. A lot of people just want to drink. Some want to know all about the ingredients and history of the drink and when they do, we'll tell them. If they don't, we let them get on with the drinking and enjoying their friends."

> "The skill of a bartender to me is making a really fast psychological assessment of a person and finding a way to direct that mood."

Despite the fact that White Lyan won countless awards and was even hired once by Beyonce for a post-gig party, critics were initially quick to question Ryan's tactics. "Although bottled cocktails were huge in the 1920s for practical reasons, so I'm not quite sure what people were upset about." The upset quickly waned when *The New York Times* called White Lyan "The Most Important Bar to open in the last decade."

Critics did not discourage Ryan, who opened a new bar called Dandelyan in a stunning riverside location within the Mondrian Hotel. The menu was based on modern botany. "If White Lyan was all about proving that there are other ways to do things, Dandelyan was about demonstrating that nature is complicated." New flavours were explored by delving into the composition of plants. "We looked at why plants employ the tactics that they do: how they grow or defend themselves can teach us a lot about how to get the most interesting flavour from them."

As a master of biology and philosophy, Ryan has always been fascinated by the language (or lack of it) around taste and flavours. "I got interested in how you could touch people with food without them necessarily knowing about it or understanding it. I want to explore a language that will keep things interesting for people without alienating them." The approach at Dandelyan was to devise regularly changing menus that played with concepts of nature. One menu, which also offered many alcohol-free options, explored the breakdown of botanical categories into mineral, cereal, vegetable and floral. Another looked at the vices of botany: faith, lust, rock 'n' roll and currency. Each menu had tasting notes and a map to help people decide what to order. "Creativity is about communicating with people and making things feel relevant, so that's what we aimed for."

Ryan closed White Lyan in April 2017, not due to any lack of success but because once he had achieved what he set out to do—to popularise the bottled cocktail—he felt ready to start a new debate. He opened Cub, a cocktail restaurant in Hoxton, in partnership with Doug McMaster, who runs the UK's first-ever zero waste restaurant in Brighton, and flavour scientist Arielle Johnson, who is an MIT director's fellow and ex-NOMA resident scientist. Together, they conceived a hybrid between a bar and a restaurant, offering a heady flow of drinks and dishes. "People say bartenders should learn from chefs, but for me, they are one and the same. People drink with food and I wanted to bring those worlds together in a new way." Cub makes a night out far more relaxing: the only choices you have to make are whether you are a meat eater, vegan or vegetarian, and whether you are drinking alcohol or abstaining. "So you just chill and we take care of everything."

Cub has taken Ryan's sustainability agenda to the next level, focusing on produce, design and people. All the food is from sustainable sources and ensures the farmer gets a fair deal. Its table tops are made from recycled yoghurt pots and its walls from breathable clay that filters the restaurant air. But for Ryan, sustainability also means preserving his team's energy: "We prep everything so our staff isn't worrying about running out of anything or scrambling around for ingredients. We have some people down to four services a week. We don't want to break people."

toilets

"I want to explore a language that will keep things interesting for people without alienating them."

Talking about future ambitions, Ryan says: "I'm very interested in exploring how people enjoy food, drink and time with their friends in other cultures and how we can bring those foreign energies into our cultural experiences. I love the idea of bringing people together in ways they are not used to."

The ever-unpredictable Mr Lyan closed down Dandelyan in March 2019, after it won first place in the World's 50 Best Bars list, World's Best Cocktail Menu at the Spirited Awards, Drinks Menu of the Year, Bar of the Year and Bartender of the Year at the CLASS Awards, to replace it with the bar concept Lyaness. He is also planning to launch new bars in Amsterdam and Washington DC. "There's so much I think we can do, and so much we want to challenge, discuss and create in this industry that it makes sense to burn it down, start afresh, and rise again as something brighter, shinier and more fitting for where we're at now. Now it's time to pull out the real weird stuff. Here's to keeping it weird."

How to get stuff done in London:
London is so big that there is always enough critical mass to support something. But people here are time poor, so you need to fit a lot into little time. Also you need to be honest about what you stand for, because Londoners see through everything.

What makes a Londoner?
They don't take shit and they band together when things get bad. And they always push for excellence.

London in a nutshell:
It's diverse, multi-layered, rich and always ahead.

Ibrahim Kamara

Subverting stereotypes with imaginative styling

"I'm not purposefully changing how black masculinity is represented.
I'm just expressing myself."

As a celebrated stylist and editor-at-large at *I-D Magazine*, Ibrahim Kamara challenges the ways black men, menswear and masculinity are presented in fashion. His disruptive styling mixes fantasy with images of 'the new Africa', which he describes as the freedom to claim your space and express yourself. "As black boys, we are taught the world isn't built for us. But now we're starting to reinvent ourselves without letting the colour of our skin limit us."

His work, which has appeared in *Interview Magazine*, *Vogue* and *Dazed & Confused* and in campaigns for Nike, Dior and Stella McCartney, subverts stereotypes of not just masculinity and femininity, but also Africa and the African body. His work is part of a larger movement of artists from Africa and its diaspora who are creating a new aesthetic around belonging and identity. "At home, black boys traditionally had to be tough. But slowly, they can finally be vulnerable. I'm allowing black boys to dream and say 'I want to be Prime Minister' or 'a ballet dancer'. We are demanding space."

Ibrahim, or Ib as he likes to be called, was born in Sierra Leone and raised in Gambia. "We grew up on BBC and CNN, which didn't help us to be imaginative. African kids need to form their own imagination. European kids grew up watching much more imaginative stuff on TV so they don't need to work at it so hard." At age 11, he moved to London and set out to follow the path his parents had dreamed for him: that of being a doctor. He studied chemistry and biology but soon dropped out to enrol instead in the Fashion, Communication and Promotion course at Central Saint Martin's.

"Central Saint Martin's pushes you to think the London way, to always think 20 years ahead, in terms of style, idea and concepts. Studying there helps you to know yourself. You can create subcultures there that you couldn't create anywhere else. In that sense, I felt like it was an analogy for Africa, which is going through exactly that phase right now."

Ib spent time working for Maison Margiela and assisted Barry Kamen, the model-turned-stylist (and brother of Nick-from-the-Levi's-ad), who was part of the revolutionary Buffalo collective of models, stylists and photographers. The movement formed the inspiration for Neneh Cherry's famous song 'Buffalo Stance' and is credited with having predicted the increasingly gender-fluid fashion scene we are seeing now.

What he learned from Barry seeped into his 2016 photography exhibition, *2026*, for which he spent time in Johannesburg with photographer, collaborator and close friend Kristin-Lee Moolman, dumpster-diving in the shantytowns for props. Using the scarves, jackets, boots and dresses they found, they transformed friends of Kristin-Lee into models that represented their idea of what men, and masculinity, will look like in a decade's time. The end result has a distinctively African flair yet renders an imaginative world, free of rules. "*2026* was my coming-out story and a portrayal of everything I had wanted to be as a child." The photographs were included in the 2016 Somerset House exhibition *Utopian Voices Here & Now* and opened up conversation around gender fluidity and black masculinity. "I don't want to be the face of anything, though. I'm not even purposefully changing how black masculinity is represented. I'm just expressing myself",

> "Edward Enninful exposed the lie that black doesn't sell. If you tell culture 'look at this person,' it will."

Ib comments. In late October 2016, Ib and photographer Jamie Morgan went to Paris to cast and style young French African men for a special series that was an ode to his mentor Barry.

The exposure Ib gained from the Somerset House exhibition opened up new avenues. He found himself working for brands such as Nike, Dior and Stella McCartney, the latter taking him and photographer Nadine Ijewere to Nigeria to style and shoot the #StellaBy collaboration, using classic African landscapes and male models dressed in Stella's womenswear. He also did the wardrobe styling for London musician Sampha's 36-minute film *Process*, which accompanied the release of his eponymous debut album. It was directed by Khalil Joseph, who also worked on Beyoncé's film *Lemonade*, and was partly shot in Sierra Leone's capital, Freetown. "Getting to create something so new in that environment was incredible. It was like coming home for me, in every sense of the word." Ib's styling was an exciting mix of traditional Sierra Leonean fabrics and Western-inspired clothes, reimagined as magical, scary and majestic costumes.

Ib strongly believes that fashion has a responsibility to be representative of its consumers and therefore inclusive. "It has to show beauty in all shapes. Look at what Edward Enninful (editor-in-chief of British Vogue) has done: he put two black women on the cover of Vogue and exposed the lie that black doesn't sell. If you tell culture 'look at this person,' it will."

In 2018, he collaborated with Kristin-Lee again, this time joined by British fashion designer Gareth Wrighton. Using found trimmings from Johannesburg dumpsters and working with a local tailor, they created a collection of suits, jumpsuits and costumes, which they then photographed for their New York mixed media show *Soft Criminal*, a convergence of visuals, artwork, fashion and a live runway show. "It had the energy of a catwalk collection, but with more depth." The show told the story of three rival families, 'Old money', 'New Money', and 'Not In It For The Money'. They concocted the story of a century-old royal family and the 'new money' rivals who attempt to overthrow their kingdom, helped by the 'Not In It For The Money' gang of lawless rebels. It took inspiration from the movies, art and politics and featured guns, boxing gloves, knives, and a lot of tulle. The fantasy inspired the subversion of what a fashion show is supposed to look like. "We pushed our imagination as far as possible, because once you live in a fantasy world, ideas are endless and there are no rules. Essentially, what I'm aiming to do is create space for people from my background who might not have hope. I want to tell culturally driven stories and create new stars."

Despite all his travels, Ib considers London home. "London is a very accepting city. Black and Asian kids come together here and they support each other. And London fashion is run by young people, not the big fashion houses. The forerunners are the young creatives. You're always surrounded here by people who are making an effort. It creates this bubble of progressive thinking."

He explains how there isn't really a London style to speak of. "Taste here is experimental and raw. Londoners are willing to try stuff, fail, and then just walk away if it didn't work and reinvent the wheel."

How to get stuff done in London:
It's expensive here so you need a job to support your creative endeavour. But then if you work hard, you'll make it. And if you make it in London, you're set. The colour of your skin doesn't stack up against you here like it does in other places.

What makes a Londoner?
An accepting nature and an attitude of 'there is no right or wrong.'

London in a nutshell:
It's pure brilliance: we push ourselves to be the best. London is the best city in the world.

Andrea Román

AR Ceramics

Limelighting London's ceramics craze

Andrea Román attributes her love of clay to growing up in Mexico and the influence that its pottery communities had on her when she was a child. Despite completing a degree in Industrial Design where she learned how to work with a wide variety of different materials and tools, her most valued tool has always been her hands. "I love being able to control every element and see a completely finished product appearing from my hands. And clay is the perfect material for that —so easy to manipulate and transform."

As a ceramics designer working under the name AR Ceramics, Andrea creates utilitarian pieces in a style that has become her trademark: simple, straight lines, unglazed finishes and a neutral, nude colour palette. She prefers to only use glaze when the functionality of the piece demands it, and celebrates the natural properties of clay by experimenting with marbling and texture. References to stone, sand and soil are combined in timeless shapes that function as cups, bowls, vases, soap dishes, incense holders, planters and plates that have not escaped the attention of popular restaurants—such as the much-acclaimed Hide Restaurant in Mayfair—and hotels, as well as shops and, increasingly, ceramics-obsessed Londoners. "There's a revival of crafts happening here. People are not just into making things themselves, they also have the desire and means to invest in handmade products that will last longer."

"A restaurant might order 200 plates, expecting them to be chip resistant and dishwasher safe. But even when I tell them they're not designed for restaurants and they're five times more expensive than porcelain, they still make that investment because handmade tableware has that added value. And London diners appreciate it."

Her move to London was a tumultuous one. When a ceramics teacher at the Universidad Nacional Autónoma de México encouraged her to pursue ceramics and ensured that one of her end-of-year pieces—a spinning cup—was entered in the 2013 Biennial of Utilitarian Ceramics in Mexico City, Andrea received an Honourable Mention. This won her a position working with Mexican designer Ariel Rojo, who runs a studio focused on improving quality of life through design solutions. She focused on graphic design and crafts and thrived under his tutelage. But Andrea dreamed of pursuing a master's in Glass & Ceramics at London's Royal College of Art. Her boyfriend and future husband, meanwhile, wished to enter Imperial College London. They applied to their respective colleges and were both accepted; however, only her partner was successful in his application for funding from the Mexican government. Unable to afford the fees, Andrea stayed behind in Mexico and they embarked on a long-distance relationship. "A year later, we were at breaking point. Either we went our separate ways or I moved to London. It was Ariel who pushed me to take the leap and told me his door would always be open if I wanted to return to Mexico."

"People have the desire and means to invest in handmade products that will last longer."

She made the move and scoured London for a job in product design. But everywhere Andrea went she was told she was "too much of a free spirit." Missing working with her hands, she discovered the Turning Earth ceramics studio in Hoxton. "Places like that, and Kiln Rooms, give

> "Sharing tools is like sharing fingers. You just don't do it; they become part of your body."

Londoners the opportunity to affordably try out the craft using the right materials. I had only ever tried slip casting and moulds until then, and had never turned the wheel." She decided to spend all her savings on renting a wheel and teaching herself to throw.

Andrea produced more pots than she knew what to do with. "I knew it was time to go professional. I wanted to tell a story: make a website, get business cards made and try to make this my living." She joined a crafts market and sold out. This was the moment when the potential of her business became clear.

Her Instagram account, where she documented everything she was doing, garnered the attention of the owner of Botany, a plant shop in Clapton, who reached out and asked her to make 50 planters for her. "That was a huge order for me at the time. Angela [Maynard, the shop's owner] and I worked very closely to produce an exclusive line of planters that were only to be sold at Botany. And because she had such a unique way of presenting her plants and my planters, a lot of work started coming my way. I owe a lot of my exposure to her."

Angela's desire for Andrea to work exclusively with her put Andrea in a tricky position. "But then I realised that creating small and exclusive collections for different shops, hotels and restaurants without repeating objects is the best way for me to run my business. Instead of simply ordering off my catalogue, I'll sit down with a client and think about what they need—what clay, glaze or size. I then create a collection in line with that."

One such collaboration was with the online store The Future Kept, whose brief to Andrea was to create a collection of products for everyday rituals that would allow people to "start their morning clear of mind, end it with an acceptance for what has been, and celebrate the rituals and moments that each day brings." The result was a hand-thrown set consisting of a cup for coffee and a bowl for fruit or granola, made with textured dark clay and a transparent clear glaze, and an incense holder, match holder and match striker in pale stoneware. "I would have never created those pieces without that specific brief. These exclusive collaborations definitely make my work richer."

Although she does not sell pieces from her exclusive collections to other commercial clients, she will sell individual pieces to private customers. "If a restaurant asks for 150 plates, I'll make 180. Some of them come out badly, but those that turn out perfectly, I'll sell one by one."

One of her most recent collaborations was with luxury hotel Heckfield Place in Hampshire for whom she created a line of 350 exclusive pieces, including soap dishes, bath salt containers, bowls, saucers and honey pots, mostly produced in white clay. "That project had me in a trance, working to the same, strict schedule every day, turning out every piece with my own hands." Despite her success, Andrea still does everything herself, from making the pieces to photographing, marketing, selling and shipping them. She still works from Turning Earth, now in the Lee Valley space.

"It's a tight community of people who support each other and share tips and advice. But we never share tools. Sharing tools is like sharing fingers. You just don't do it; they become part of your body." Although she loves the studio, she does fantasise about opening her own place. "Space informs ideas, and to be able to create a space for new ideas would be a dream."

"Space informs ideas, and to be able to create a space for new ideas would be a dream."

Andrea is part of a ceramics collective called 2-7-4, a group of ten potters and designers who met through sharing studio spaces around London. They organise workshops, exhibitions and pop-up shops to introduce new ways to connect people with ceramics. In the winter of 2016, they decided to open their first pop-up shop, where each ceramicist could sell their own pieces and tell their story. Displaying their work together in one space provided a unique insight into modern ceramic practice: from porcelain and clay products to moulded and wheel-thrown work and from the functional to purely artistic work.

"Selling in this way allows potential customers to approach us in different ways, ask us about our products and see our passion. It provides us with an opportunity to open conversations about ceramics, ideas and the art of making."

When thinking about the future, Andrea says: "The goal isn't to become huge. I want to be the owner of my time. I've never pursued a particular goal but I've always been good at keeping my eyes open for opportunities. So the plan is to continue doing just that."

How to get stuff done in London:
You need to be constantly moving here. There's a lot of competition and pressure so if you sit still, you're simply shoved aside. It can feel like London is constantly trying to kick you out, so you really need to know why you're here to make the pain worthwhile.

What makes a Londoner?
A Londoner is active, creative and open. It's rare to feel like a foreigner here.

London in a nutshell:
London isn't easy.

Tom Broughton

Cubitts

Reviving London's spectacle-making history

"You can either hide from glasses or embrace them, and I chose to embrace them. I always felt that my specs gave me a sense of personality."

For as long as he can remember, Tom has been a proud wearer of glasses. As the founder of Cubitts, a company that makes stylish, handmade and affordable spectacles, his goal is to extend that pride to the 69% of the population who wears them. "Anyone who's worn glasses through school will attest to the fact that they become a part of who you are. You can either hide from them or embrace them, and I chose to embrace them. I always felt that my specs gave me a sense of personality."

Tom used his first wage packet to buy a pair of 692 frames from Cutler and Gross. He had them shipped from London and felt like the coolest person in his hometown of Leicester. "It was the most exciting thing I'd ever owned. I couldn't understand why others didn't feel similarly about their glasses."

He spent the next ten years asking himself that question, while putting his degree in mathematical economics to good use working for the consultancy firm Deloitte, among others. "That was never a very comfortable fit for me." He then had two lucky meetings. One was with Lawrence Jenkin, a master spectacle maker of 50 years who had run his family's business, Anglo American Optical. The other was with Charlie Ingham, who had worked at Cutler and Gross and shared Tom's obsession with spectacle making. Lawrence took Charlie and Tom on as apprentices, teaching them the traditional method of making frames.

"Lawrence started us off with a piece of paper, a pencil, a ruler, a protractor and a compass. He taught us such an important piece of knowledge that had been lost: where the overlap lies between design, science and optics, facial measurements and vocation. He taught me everything there is to know."

Three years later, in October 2013, Tom started Cubitts—initially as an online business—with the mission of getting people excited about spectacles. The name came from the street he lives on, Cubitt Street. "It was named after the Cubitt brothers who were famous Victorian engineers who completely transformed London's building industry: they took a traditional and inefficient industry and applied a set of principles to it to make it more efficient, transparent and honest. Their King's Cross Station, for example, is angular and simplistic and doesn't pretend to be anything else than a train station, which is very different from St. Pancras Station next door. Those were the Cubitts' principles, and today are ours: we don't try to be a fashion brand; we are clear about what we do and we celebrate it."

Tom self-funded the business using ten years' worth of savings. Six months into the venture, he was broke. His parents bailed him out, which gave him a few more months of trading. Despite looking for investment, Tom was constantly turned down, or worse, ignored. He then managed to get his products into Albam, an upmarket menswear shop in Spitalfields, which meant that Cubitts went from selling one pair of glasses a day to four.

Then, one day, investment finally came in the form of an enthusiastic customer who sent a speculative email offering to invest in the company. Tom and his first employee Joe met him for coffee that same day and made an agreement there and then. Around the same time, Tom's childhood idol, author Nick Hornby, came into the store to buy a pair of glasses. Tom cycled them over to his flat when they were ready. "It was then, I think, that I knew that this would work out."

The birth of Cubitts also coincided with the death of fast fashion. "The 90s were all about the big fashion brands: Prada and Gucci. The 2000s

were more about fast fashion and the rise of Zara and H&M. Now people are more discerning and expect the brands they choose to stand for something and to last."

> "I love the idea of exporting this quintessentially London product all over the world."

Today Cubitts sells between 50–100 frames a day directly to customers, which allows the company to sell at wholesale prices and keep the products affordable. It also donates frames to homeless charities but does not use that as a marketing tool. "We do it because I think we have the obligation to." With seven stores across London, Cubitts has ambitions to go global. "I'd love a Tokyo store. I love the idea of exporting this quintessentially London product all over the world."

An important part of Tom's mission is to bring back the incredible legacy of London's spectacle-making history, one that few people know about. The first-ever pair of glasses was made in London's Soho in 1730, when Edward Scarlett had the idea of adding arms to the sides of spectacles. Before his invention, there were only rivet spectacles and pince-nez, which would sit on the nose. "That completely changed how people wore spectacles because you went from only being able to wear them for about twenty minutes at a time to wearing them all day. That really kick-started this amazing industry, which lasted about two centuries."

Tom goes on to tell the story of how from the 1800s until WWII, Clerkenwell in London was heaving with workshops making spectacles, jewellery, watches and mathematical instruments, with each craftsperson making telescopes, microscopes and spectacles. After the war, the newly established National Health Service began giving away free glasses to the British people. This led to the closure of the workshops, as spectacle designers, manufacturers and distributors were no longer needed. "Then in 1985, the NHS decided to stop giving them away but we haven't really recovered since then. To this day, London is behind on the development of this industry."

Cubitts is trying to bring back the heyday of the eyewear industry, with special emphasis on bespoke glasses and the provision of a quality, customer-centric experience. "For 200 years, standard glasses were all made and sold in that way: with customised fitting, design and service. It's the antithesis of how things have been done in the last few years, with people being forced to shop at huge shopping centres with a conveyor belt of glasses, being bombard with options that they don't understand. Then, if your glasses break, you have to buy a new pair. In the past, glasses would last you an entire lifetime."

Tom is a big believer in technology as an enabler in making tradition relevant again. "The two aren't opposed. You can use technology to streamline things and allow people to focus on what's important." For the past three years, he's been developing an augmented reality trial tool with facial recognition experts in Germany. He calls it The Speculator. It recognises your face, places a frame on it and allows you to focus on choosing the style and type of glasses you want. He is also in the process of building a mechanism using cephalometrics, which is based on cephalometry, the study of the human head. The technology creates a 3D model of your head, accurate to a fraction of a millimetre. "It's essentially a dome that's put over your head, as if you're about to get a perm, with smartphones inside it that take a series of photos of your head to create the 3D model. It takes fitting out of the equation. Once you know your fit, you can just focus on colour, shape and material, and once you're happy,

you can just 3D print." Printing full frames that way is still a pipedream, but Cubitts is already 3D-printing components such as bridges and rim locks. Bespoke has long been the preserve of the rich but the dream is now to harness technology to make all frames in advance .

These high-tech capabilities are combined with traditional methods of manufacture. For its acetate frames, Cubitts uses a method called pin-drilling, where small holes are drilled to allow for pins to pass through, instead of using the popular heat syncing method. "95% of frames now aren't made with pin drilling anymore because it's time-consuming. Ours are, because pin-drilled frames are easier to repair. We want to teach people to appreciate their glasses: teaching them to look after and celebrate the glasses they are wearing."

Once a year, Cubitts runs framemaking classes to teach people the requisite skills. "It's like an oral tradition. Not everyone on our courses will become framemakers, but if you can pass on that knowledge, the craft will live on."

CELEBRATING EUROPEAN INFLUENCES OF THE 1930S

Known as London's 'Latin Quarter', the area now known as 'Fitzrovia' was a magnet for European immigrants and those of a bohemian bent, attracted by the cheap rents and central location.

At the turn of the 20th century, so abundant were the number of French, Italians, Swiss, and particularly Germans, that Charlotte Street became known as Charlottenstrasse.

Cubitts Fitzrovia has been designed to celebrate the European influences of the late 1920s and early 1930s, with elegant silhouettes inspired by the early modernism of our continental friends. Colour references include a soft pastel palette synonymous with the era.

An original German globe from 1929 (one hundred years after the site was built) is a small nod to the European influences of the period. S411 cantilevered chairs, developed in 1929, rest under an original Caseb light fitting designed in the same year.

Perhaps no building is as synonymous with these influences as the remarkable Isokon (or Lawn Road Flats) in Hampstead.

Designed by Wells Coates, the fluid lines and crisp pale pink are perhaps more reminiscent of an ocean liner than a 'machine for living'. Early residents include Bauhaus émigrés Walter Gropius, Marcel Breuer, and László Moholy-Nagy. A testament to the quality of the design and the modernist movement, the building feels as relevant today as it did in the 1930s.

How to get stuff done in London:
You need absolute focus in London to get stuff done. The city is full of the best engineers, designers, artists, writers, but it's also full of distractions. Without that focus, you can get paralysed by the amount of choice and stuff to do here.

What makes a Londoner?
An openness to everything: to tasting new things, to unfamiliar experiences, to learning.

London in a nutshell:
London is a collection of everything: of ethnicities, attitudes, political leanings, ideas, opportunities and villages.

Anna Murray and Grace Winteringham

Patternity

Finding meaning in the world through pattern

From a top floor studio in London Fields, Anna Murray and Grace Winteringham run Patternity, a conscious, creative organisation that works with pattern to inspire more curious, collaborative and connected ways of living. They aim to share the positive power of pattern with the world through experiences as well as research and design. Their client list includes John Lewis, Selfridge's, Penguin Random House, MOO, Kenzo, Marks & Spencer and Clarks, for whom they create clothing, household goods, stationery, book covers and workshops.

> "Once you see patterns, you can't unsee them. It makes you feel more connected to the world."

"A pattern can be many things: a repeated design; a regular, intelligible sequence; a design for crafts; and an example for others to follow. We look at pattern through these different lenses to help people become more conscious of their behaviour and help them find meaning in the design and products that surround them," Anna elaborates.

After meeting at a party in 2009, Anna and Grace bonded over a mutual appreciation of pattern and realised they had both been collecting research and imagery on the subject for years: photographs and magazine cuttings of patterns in architecture, fashion and nature. They started digitising and meticulously archiving all their material into pattern stories, whereby the tag 'stripes', for example, would include images of zebras, barcodes and the rings of Saturn. The archive attracted attention from industry giants such as Stella McCartney, H&M and Land Rover. "We wanted to give pattern a voice in a holistic way and let people appreciate the interconnectivity of life," Grace explains. Anna adds: "Once you see patterns, you can't unsee them. It makes you feel more connected to the world."

For their 2012 *Bright Young Things* campaign, which champions young designers, Selfridge's worked with Patternity to create a window display for its limited-edition hosiery *Streetshapes*. The tights—basically artwork for legs—were inspired by London's contours, featuring squares, rectangles, triangles and circles reminiscent of tower blocks, satellite dishes, grilles and tiles.

The campaign was a great launch pad for Patternity, leading to collaborations with The Barbican and Pretty Polly. In 2014, Anna and Grace created an outdoor installation for Airbnb in the form of a four-metre-long kaleidoscope in the middle of Trafalgar Square. Using mirrors and optical illusions, and with the help of experiential photography specialists Say Fromage, *Kaleidohome* documented the real-time interactions of passers-by. The resulting images were then published online. Their next project was to design a climbing wall for the Ace Hotel in Shoreditch. *Ascension* tells the story of millions of years of mountain formation as well as that of each climber's personal victory. It is decorated with a gradient pattern reminiscent of the contour lines on relief maps and on the wall next to it is a Ralph Waldo Emerson quote: "Adopt the pace of nature; her secret is patience." Anna explains: "We wanted the climbing experience to feel contemplative and positive."

In 2018, Patternity created a range for John Lewis. *Positive Patterns* is a 100-piece collection of clothing, bedding, rugs and towels that encourages people to integrate patterns into their wardrobes, homes and daily lives. Grace says: "A lot of

contemporary design lacks deeper meaning and authenticity." Anna adds: "That's why we wanted to create functional pieces that embrace your daily rituals, make you mindful of your routine and bring joy to your day."

Many of Patternity's designs are monochrome. "That's how we see the world as newborns. We have so much choice these days. Using a minimal colour scheme can help people to focus and relax," Anna continues. "Our design language of iconic geometric elements creates a rhythm and with that, a balancing effect." Grace agrees: "Patterns are a language. They can simplify complexity."

The power of pattern was also explored in a collaboration with the Imperial War Museum. Together they launched *The Fleet of Dazzle*, a line of products inspired by Norman Wilkinson's iconic 'dazzle' camouflage pattern. Designed during the First World War, the bold shapes and contrasting colours were painted onto ships to confuse the enemy's periscopes. Patternity's designs for the project, which included tote bags, T-shirts, cups and cushion covers, created a similarly dazzling effect. The museum also screened a film, *Pattern, Conflict and Unity* (directed by Lily Silverton), to educate the museum's visitors about the power of patterns and unity in overcoming conflict.

Education is an important part of Patternity's mission. In collaboration with The Wellcome Trust, Anna and Grace studied the patterns of infectious diseases and bacteria at the microscopic level and created four 12-foot window displays on Euston Road based on the repetitive patterns they found there. They told the story of disease: how it starts, how it affects the body and society, and how it can be cured. The *Infectious Patterns* campaign included an animated film about The Wellcome Trust's work in eradicating the world's most infectious diseases, and a series of pattern-making workshops where participants created their own visualisations of infection. "Pattern recognition is how medicine works, so it helped people to engage with the research around diseases in their own way, and reflect positively on such a difficult topic," Grace says.

To further spread the belief in the power of pattern to create positive change, Anna and Grace released their first book, *PATTERNITY: A New Way of Seeing*, in 2015. Published by Conran Octopus, it is a journey into pattern throughout history and across fashion and beauty, art and design, science and nature. In 2017, they followed that up with a gratitude journal. *Be Great Be Grateful* provides exercises for bringing gratitude into your life through patterns. It helps you design your life and educates you about your own patterns. "I had been keeping a gratitude journal together with my mum for a while," Anna recalls. "I realised that gratitude helps you to see the interconnectivity of things. If you're grateful for the water you're drinking, you are also thankful to plants, clouds and rain."

Anna and Grace strongly believe an understanding of patterns can drive business, too. "In business, we don't honour cycles. You simply can't always have growth; you need a period of rest. There will always be winter," Grace says, and continues to explain that a better understanding of the women's menstrual cycle, "the ultimate creative power", is underestimated, too. "Seeing patterns is living a life of harmony. Our workshops get people thinking about patterns of sleep, melting ice caps, consumption, behaviour; it helps to bring understanding and acceptance. It's a more feminine approach to life. There is a lot of ancient wisdom in recognising and understanding patterns that has served us for centuries, and we don't want that knowledge to go to waste."

"Patterns are a language. They can simplify complexity."

How to get stuff done in London:

Anna: You need a hard shell, time in nature, people that support you and an awareness of your menstrual cycle (if you have one!).

Grace: A sense of belonging and the ability to ask for help. And remembering that we are human beings, not human doings.

What makes a Londoner?

Grace: Londoners are transient people with hardened egos and a lot of resilience.

Anna: We're curious, ambitious and make good collaborators.

London in a nutshell:

Anna: It's illuminating, sparkling and, essentially, all about its people.

Grace: It's its own cosmos.

Julius Ibrahim

Second Shot Coffee

Making specialty coffee count

Second Shot
Bringing people together by tackling homelessness one espresso at a time
Chat to us to find o

Second Shot
Help Combat Homelessness
& PAY IT FORWARD

From an unassuming location in Bethnal Green, Julius Ibrahim runs a specialty coffee shop with a twist: Second Shot Coffee trains and employs homeless people for six months at a time and helps them find employment afterwards. It also runs a 'pay it forward' scheme whereby customers can prepay for food and drink for those in need.

> "I wanted to build a cool coffee brand that provided an exceptional product and that solved a problem in the community—in that order."

As a multi-roaster cafe, Second Shot takes coffee very seriously and has built up quite a reputation with local coffee lovers, winning a *Time Out* Love London Award in 2018. It introduces customers to a variety of beans by changing roasters every month or so, and has worked with some of London's most reputable companies, including the much-awarded Square Mile. "From the start, I knew that I wanted to build a cool coffee brand that provided an exceptional product and that solved a problem in the community—in that order." The emphasis on serving high-quality fare has meant that Second Shot attracts an interesting mix of clientele, representative of the area's diversity: from Cockney blue-collar workers to local creatives and entrepreneurs and, of course, the homeless community itself. Many of its customers might only find out about the cafe's mission on a third or fourth visit, when they notice the constantly changing drawings on the wall. Each time a patron decides to 'pay it forward' and purchases a coffee or sandwich for someone else, they draw the item on the wall. When someone comes in to claim it, they simply wipe it off. "Seeing your drawing disappear within the space of one visit is very satisfying. It makes the impact of your contribution real to you."

Not only does the cafe donate food and drink to those who need it, it also creates a destination for the dispossessed to feel welcome, visible and respected. "We have managed to build a community. Everyone who visits us has the same experience and is treated equally." The interactions that occur in that 250-square-metre cafe go a long way towards changing perceptions of homelessness.

The cafe's loyalty card serves as a clever marketing tool: a customer can rip it in two and give one half to any homeless person they encounter in the street, who can then exchange it for food and drink. People can also donate via the website, thereby extending the café's reach beyond East London borders.

Second Shot works with established charities Crisis and Centrepoint to identify homeless individuals who would benefit from the programme. The trainee is paid a minimum of the London Living Wage and stays in close contact with the charity—which offers stability and support—throughout the training. "The two most important lessons of social enterprise to me have been that you need the buy-in from whoever you're trying to help, and that you need to pay them. You can't train someone with an empty stomach who hasn't slept."

Julius has always been something of an entrepreneur and fan of the restaurant industry. When he was very young, he baked and sold brownies; as a teenager, he worked in an Italian restaurant and later still, he flipped burgers at Bleecker Burger. The summer before university,

he enrolled in a leadership internship run by a management consultancy firm. It focused on problem solving, team building and critical thinking. It was here that someone told Julius about ENACTUS, a global non-profit organisation composed of student, academic and business leaders who use their entrepreneurial skills for social good. That conversation changed his life. When he eventually started his Economics degree at UCL, the first thing he did was to join the ENACTUS group there. In true Julius style, he threw himself into it completely, spending about 70% of his time on his project leadership role consulting for a struggling community cafe. The rest of his time was split between studying and working in kitchens.

"Homelessness is such a visible problem that impacts all Londoners on a daily basis."

A year and a half into his studies, Julius became the President of ENACTUS' UCL branch and made the difficult decision to cut the team from 80 to 10 people, and the number of projects from seven to two. "I realised that we shouldn't aim for numbers but instead focus on creating life-changing impact." One of their projects was the launch of a mobile beauty salon run by victims of domestic abuse; another helped kids at the Great Ormond Street Hospital. But the community that the team was most keen to help was that of the rough sleepers around UCL, in Bloomsbury. "It's such a visible problem that impacts all Londoners on a daily basis." Julius was frustrated at the lack of a workable solution, despite trying to get several projects off the ground. He realised that none of them would have an impact unless the person behind the idea was actually implementing it and harnessing their specific skills and interests. "And mine was hospitality. I liked coffee but I wasn't passionate about it. But from talking to people, I realised coffee would make a great vehicle for change."

Halfway through his university degree, Julius decided to take a year off to focus on tackling homelessness with a coffee venture. He found investors interested in funding a pop-up but no one willing to invest in the fixed-location, permanent solution that Julius knew would have the most impact. "I was 20, had no experience, no money and no contacts. I spent the first nine months of my year off trying to build this company, with nothing to show for it, before I came across Social Investment Tax Relief, which allows individuals to put their investment in social enterprises and deduct it from their taxes. That changed everything for me."

Julius never did finish his university degree. Instead, he took a short specialty coffee and barista course and worked in a coffee shop for two months. In February 2016, he finally found the necessary funding and Second Shot opened three months later. Two and a half years on, eight people have gone through its training and found employment, and more than 8,000 coffees and 3,000 meals have been donated. As of early 2019, Second Shot will have its second location, in Marylebone's Church Street, bringing yet more people together by tackling homelessness one espresso at a time.

How to get stuff done in London:
You need a strong belief in yourself and in what you're doing, because it's easy to get lost in London.

What makes a Londoner?
Most people come here alone, so they're open and friendly—they have to be. We have this feeling of being in it together.

London in a nutshell:
It's the city of choice. Londoners know what they want and you need to cater to that.

Fabien Riggall

Secret Cinema

Pioneering news ways of experiencing cinema

Once or twice a year, the hottest ticket in London is to an edition of Secret Cinema. Fabien Riggall's company has been creating fully immersive cinema experiences that blur the boundaries between audience and performer, set and reality, and cinema and festival, since 2007. Secret Cinema builds entire worlds based on iconic movies and invites the audience to become part of the story.

> "We live such premeditated lives these days. Secret Cinema gives people the opportunity to lose themselves."

When people purchase a ticket online, they receive a set of instructions on the character that they will dress up as and the meeting location —the actual venue is not disclosed. On the day, they are taken to the venue and instantly sucked into a unique world: up to 5,000 people walk through the different sets of the film, become part of it, watch actors play out scenes and finally view the actual film.

Since its inception, Fabien and his team have created 46 such worlds from films including *Metropolis*, *One Flew Over the Cuckoo's Nest*, *Lawrence of Arabia*, *La Haine*, *Ghostbusters*, *Casablanca*, *The Grand Budapest Hotel*, *Back to the Future*, *Star Wars: The Empire Strikes Back*, *Dirty Dancing*, *Blade Runner* and *Shakespeare's Romeo + Juliet*. Each time a new venue in a different part of London is used, and audiences can reach 100,000 people, all sharing a desire for mystery, adventure, danger and romance. "We live such premeditated lives these days. Secret Cinema gives people the opportunity to lose themselves. Everyone loves the idea of being in a movie. We allow everyone to be in one and create their own story within it."

"Growing up, I wanted to be an actor. One day I watched *Once Upon a Time in America* and related so much to the Robert de Niro character, Noodles, and had this huge crush on Jennifer Connelly, and I think my desire to be in movies grew from that." When he was a little older, Fabien started going to music festivals and asked himself what it would be like to go to a festival like Glastonbury or Reading but for movies. In 2003, Fabien set up Future Shorts, a regular film night during which a few short films selected from festivals around the world are screened, accompanied by DJ sets and live music. Future Shorts is still held all over the world—in 100 different cities in 40 countries so far—and can be organised by anyone who applies. Fabien recognised the power cinema has to build connections and realised that people were not coming to see a particular film but because they knew they would experience something special. "I wanted to build a community of movie lovers who loved cinema so much they wouldn't even care which movie they were about to see."

Four years later, Future Cinema—followed by Secret Cinema—was born with a screening of *Nosferatu*. Since then, the company has created 46 productions, travelled the world and worked with some of the industry's biggest studios. "It hasn't always been smooth sailing and we didn't make money for a long time." In 2013, the opening of Brazil was cancelled at short notice and in July 2014, the *Back to the Future* event was famously postponed at only a few hours' notice, with full refunds and ticket exchanges as a result.

"There's so much to think about and there's so much detail and so many people involved. But we have always had supporters. Kathleen Kennedy [one of Hollywood's most powerful producers], for example, just took a gamble on us. Despite knowing about *Back to the Future*'s late opening, she recognised that what we did was helping to build the future of cinema and she helped us get the rights to *Star Wars* after we'd been trying for years. It's all a gigantic undertaking but to me, it always felt like I was building an experience for a loved one."

There is often a social message in Secret Cinema productions. For *Shawshank Redemption* in 2013, the team transformed Bethnal Green Library into a courthouse where each audience member was charged with a crime and tried, then taken to a blacked-out bus and driven to prison. "It was like being incarcerated in America, and it allowed people to get a glimpse of what imprisonment might feel like." They then worked with various charities to push the debate around the penal system forward. In August 2014, Secret Cinema organised a charity screening of *Dead Poets Society* to mark the death of actor Robin Williams and donated all proceeds to the mental health charity Mind. In December 2014, it simultaneously screened Charlie Chaplin's *The Great Dictator* in Rome, London, New York, Los Angeles and San Francisco as a response to Sony pulling the theatrical release of *The Interview*, a film starring Seth Rogan and James Franco as CIA recruits tasked with interviewing and assassinating the North Korean leader Kim Jong-un. The screenings were accompanied by speeches, music and performances and were in support of Article 19, a charity dedicated to freedom of speech. Under the banner of Secret Protest, Fabien and the team organised simultaneous protest screenings of Albert Lamorisse's 1956 film *The Red Balloon*, followed by the 1995 Bollywood film *Dilwale Dulhania Le Jayenge*, at Calais's refugee camp The Jungle and in 20 other countries, including Palestine, the UK, the US, France, Japan, Taiwan, Kenya, Tunisia, Germany, Italy, Finland and Belgium. Proceeds from the London event were donated to the Refugee Council, as was a portion of the proceeds from the *Star Wars: The Empire Strikes Back* screenings.

Every person's experience of a Secret Cinema event is different: you choose how you walk around, who you interact with, what you skip. There are some rules though: mobile phones and photography inside the venue are not allowed. As the name suggests, secrecy is a big part of Secret Cinema. In its early days, the audience would not even know what movie they were going to see. These days, the big productions operate under the name Secret Cinema Presents, but Secret Cinema Tell No One (a smaller, more intimate experience) and Secret Cinema X (which previews upcoming releases) still operate with secrecy as a core value, not revealing the film's name until the last minute.

"I want to make a movie and know it'll exist as a building."

In 2017, Secret Cinema X showed *The Handmaiden* ahead of its general release by Curzon Artificial Eye. The audience, unaware of which film would be screened, was asked to come dressed with a black tie and carrying a notepad so they could communicate, as speaking would be strictly forbidden. During the film, the story was played out on stage, with actors performing scenes behind a screen. As soon as the end credits rolled, the venue transformed into a nightclub.

> "I want us to realise we're more than data. We're facing a mental health epidemic and there's a need to connect with each other in new, surprising and freeing ways."

The Handmaiden grossed more than half a million pounds at the UK box office over the four days of the Easter holiday alone, nearly a third of which came from Secret Cinema's pre-release screenings. The pre-release model could prove an interesting one for the big studios. "My vision is that of a new system for release, whereby a studio can launch a new movie with a Secret Cinema-esque experience, with limited and high-value tickets, after which the cinema version opens. From working with studios such as Disney, who are really the originators of immersive experiences, I know that our model is inspiring to them."

Secret Cinema has built great relationships with the studios, in part because it puts the films back in the box office. "With *Star Wars: The Empire Strikes Back*, revenue from our productions was about the same as the original." The film remained in the UK box office Top 10 for 11 weeks, generating a total of £6.45m.

Not only has Secret Cinema changed how people experience cinema and created new potential revenue streams around film, it has also made an impact on the city itself. Each production uses an existing space or building and completely reimagines it. "We've done 46 films now and for each one, we've taken a building and reimagined the space. Whereas we used to take a space for two or three nights, we now occupy it for 40 or 50 nights. After we leave, the building often morphs into something new—flats or event spaces."

Fabien still oversees Secret Cinema and its staff of 50, but does not run the day-to-day business anymore and is no longer the creative director for every production. Instead, he is setting up a new venture that will focus on producing films that influence law and culture.

"I'm interested in way too many things: in real estate and the future of theatre, and what the new church might look like and how restaurants will develop. But most of all, I want to produce films that connect to social issues, such as inequality and mental health. I want to make a movie and know it'll exist as a building. Like taking the *Inconvenient Truth* model, but extending it to space. I want to continue to create new ways of imagining how to use space and resist how we're all absorbed in our own worlds."

On the subject of the social unity inspired by Secret Cinema events, Fabien says: "Everyone keeps talking about content. It feels like we're just filling our platforms with content created for algorithms. People are lonely because of technology. Netflix is incredible but it makes you spend all day in front of a laptop. I want us to realise we're more than data. We're facing a mental health epidemic and there's a need to connect with each other in new, surprising and freeing ways."

How to get stuff done in London:
You have to believe in yourself and in your choices. You can't care too much about the consequences of your actions.

What makes a Londoner?
A thirst for adventure and love of mystery. London is such a mysterious city, with tons of hidden places and dark alleys. Every day here is an opportunity to discover some small corner you never knew existed.

London in a nutshell:
London is full of nostalgia, eccentricity and romance. It's amazing and it's hardcore, it brings you up and takes you down, you can love it and then hate it. But it's toughness that makes people here so ambitious.

Asif Khan

Inspiring a new future for architecture

From a light and spacious workspace in London's Cambridge Heath, Asif Khan runs a multiple award-winning architectural studio of 22 people, working on imaginative projects that range from event pavilions and installations to furniture, exhibition design and large-scale buildings. His work is as much about creating structures as it is about crafting experiences: "Thinking of design as the making of a cultural situation is more interesting to me than thinking of it as the creation of an object. We think holistically about everything we make and consider our responsibility as creators of experiences, so we don't just make places to be in but places that stimulate people's creativity, and make them imagine possibilities that didn't exist before."

"Thinking of design as the making of a cultural situation is more interesting to me than thinking of it as the creation of an object."

Born and bred in London, Asif has worked all over the world, but one of his latest projects is set to really make a mark on his hometown. Together with architects Stanton Williams, Asif and his team were selected to design the new Museum of London in West Smithfield, beating some of today's leading architecture studios to win the tender. Home to artefacts of the capital's history from prehistoric to modern times, the museum holds more than six million objects, making it the largest urban history collection in the world. The new building will allow the museum to double its visitor intake to 2 million and is set to open in 2021. "Public spaces have the power to change not just a city, but individual lives as well. We want the Museum of London to be a place where everyone belongs, and where the future of London is created."

Asif is known for work that plays with—and encourages—belonging, inclusion and participation. He explains that this is not just due to a personal interest but also because a lot of contemporary architecture briefs demand it. "Any city is a participatory project and a reflection of the society that builds it. These days, people want to relate to their neighbours in new ways and are open to new experiences, so when you look at any site, you need to look for opportunities for how people could interact in that space, occupy it and make it their own."

His 2014 Sochi Winter Olympic and Paralympic Games pavilion *MegaFaces* for Russian telecommunications network MegaFon was quite literally about making a space your own. Visitors had their 3D photos taken, which were then relayed to the kinetic facade of a structure similar to a pin screen. The photographs were transformed into three dimensions, to recreate three faces at a time, and magnified by 3,500%. The sculptures, dubbed The Mount Rushmore of the Digital Age, measured eight metres high by up to 2.4 metres deep. Each visitor received a live webcam link to the moment their image appeared on the pavilion so that they could share it on social media, giving a whole new meaning to the word selfie.

It was a follow-up to Asif's work for the 2012 London Olympics, Coca-Cola's *Beat Box Pavilion*, which he created with architect Pernilla Ohrstedt. As they made their way up to a panoramic view of the Olympic Park, visitors interacted with sound by touching any of the structure's 200 interlocking ETFE (a fluorine-based plastic) cushions, which were embedded with innovative sound

technology. All the sound samples—including a human heartbeat and trainers squeaking on a court—were recorded by music producer Mark Ronson as part of Coca-Cola's Olympic *Move to the Beat* campaign.

Growing up with social workers for parents gave Asif an appreciation of the power of human relationships. He had a passion for science at a young age, was always taking things apart, and developed "a burning curiosity about the relationship between the body and our mind, the microcosmic, the external and the internal worlds, and about what makes us ourselves." Asif initially wanted to pursue medicine but felt it lacked inquisitiveness. So, after a gap year in Japan that sparked a lifelong passion for the country and its culture, Asif did a foundation course at the Prince's Foundation that bridged craft and city-making. His desire to destruct and construct led him to continue his education at University College London's Bartlett School of Architecture. "I was always on the edge of failure there because it all became too cerebral for me. It wasn't even that I wasn't driven. If anything, I think I was over-driven." Despite failing his first year, he graduated in 2004 as the best student in the faculty, was awarded the Donaldson medal and received a full scholarship for further study at the Architectural Association, which counts architecture giants such as Zaha Hadid and Richard Rogers among its alumni.

Property developer Jane Wood was the first person to commission Asif as an architect after she heard his Pecha Kucha presentation about one of his student projects. Jane wanted to regenerate her town of Littlehampton through architecture in order to attract a different kind of visitor. She became a mentor to him. "Jane taught me so much: to create things appropriate to the space; to build relationships with builders; to really look at where the money goes; and to see budget as a framework, not a limitation."

The starting point for the project was the idea that fish and chips taste better in the sea air. Named *West Beach Cafe*, the eatery facade was constructed of galvanised steel and large sash windows that open up completely, like a

"We're trying to figure out how to get people to experience the sky."

doll's house, allowing the building to change with the weather and transform into an outdoor auditorium. Everything, from the cafe's furniture to the lighting, signage, steelwork and window frames, was handmade by local craftspeople. *West Beach Cafe* was a follow up to *East Beach Cafe*, designed by much celebrated architect Thomas Heatherwick and also commissioned by Jane. "You don't often get people commissioning structures for the love of architecture. But she knew that interesting structures like ours would be what sold the town to visitors."

At its core, Asif's body of work is an exploration of how people relate to each other and to the natural world. In 2016, he designed one of four Summer Houses at London's Serpentine Gallery that were to be a tribute to Queen Caroline's Temple in Kensington Gardens. Built in the early 1800s, the Temple had been aligned by the architect with the direction of the sunrise on the Queen's birthday, so Asif decided to create a structure that would reflect this and form a line from the old summer house to the rising sun. That same year, Asif developed three temporary plant-covered pavilions for MINI Living as part of the London Design Festival. *Connect, Create and Relax* were all inspired by the Japanese idea of shinrin-yoku, or forest bathing, and gave Londoners the chance to have meetings, work or enjoy a moment of peace right in the midst of bustling Shoreditch. His 2018 wood-based installation *Tempietto nel Bosco* in The Palazzo Litta during Milan Design Week also offered

refuge to visitors, with its interconnected rooms and corridors leading to a space filled with hammocks. For his Hyundi Pavilion at the 2018 Pyeongchang Winter Olympic Games in South Korea, Asif's inspiration was space. The 10-metre-tall structure was spray-painted with Vantablack VBx2, a substance that absorbs over 99 per cent of light. Miniscule white lights poked out of its sides, which made it look like a vast starry night. "I wanted to create the effect of a window cut into space."

> **"I like to think of a project as a piece of theatre and, as such, I'm interested in who the protagonist of that play is."**

Asif laments what he sees as London's unnecessary fetishisation of all things old. "That's very problematic for young architects. You have to know the history of architecture and understand it, but then put it aside. I don't want to respond to the existing discourse. I tell my team to think of a skyscraper as a mountain or a cloud, or of a cultural institute as a health centre." His readiness to scrap the rulebook has garnered the attention of an international client base. "I love working abroad. London is an enigma to me. When you're born here, it's hard to see how the city works because you're so much *in* the system. I find it easier to understand other places."

Currently, Asif and his team are working on the Tselinny Centre of Contemporary Culture in Almaty, Kazakhstan. "For that one, we're trying to figure out how to get people to experience the sky. That's important because we want to manifest the landscape as a performance space and embrace the Kazah idea of nomad living."

In 2016, he was shortlisted from 1,715 applicants for the new £83 million Guggenheim Museum in Helsinki. Despite the fact that he didn't win, it is still one of the projects Asif is most proud of. "We were so excited about what we had designed and learned a lot from the process. The experience grew the studio both in terms of its thinking and its practice." The process informed how Asif and his team still work: everyone he employs is a maker in their own right and the studio operates like a giant lab, complete with 3D printers, Japanese saws and wood-cutting machines. Every iteration of a Khan design is extensively tested, iterated, re-tested and re-prototyped over and over again, often at many different scales. "We're big believers in learning through doing and unless you see something come to life, it's hard to get excited about it or learn from it."

Ultimately, his work is completely human-centric. "It's about understanding the way we see ourselves as human beings and how we digest the experiences around us. I like to think of a project as a piece of theatre and, as such, I'm interested in who the protagonist of that play is. Whether it's a one-week, one-year or permanent creation, we want the experience to be alive and reach the lives of as many people as possible."

How to get stuff done in London:
London is not a meritocracy: you can be successful here and not be very good at what you do. Like in any other city, who you know and how much money you can put on the table, matters. But Londoners do respond to people who believe in what they do. So with a healthy dose of perseverance and a genuine sense of purpose, you can make it as well.

What makes a Londoner?
Londoners are adaptable: they have had to either make a change to come here or, if they grew up here, get used to the constantly changing environment.

London in a nutshell:
Living in London is like being in a play with an ever-changing cast. Everywhere you look, history is in front of you and in the making.

Honey Spencer

BASTARDA

Converting Londoners to natural wines

> "I've always had a problem with the culture of sommeliers. I've never understood why a product made by farmers is then served up by sommeliers in white coats."

If you want to know about wine, talk to Honey Spencer. As one of London's most imaginative sommeliers and the co-founder of BASTARDA, a collaboration between food and drink tastemakers, she has been leading a steady revolution in London to get biodynamic, organic and natural options onto the wine lists of some of the city's top hangouts.

Honey was introduced to wine during her time working with Jamie Oliver in early 2011. She had worked in bars while at Kingston University, Bristol—where she studied international business, languages and marketing—and was hired as a bartender at Jamie's 15 in Shoreditch. "I had my eye on a position in the marketing department, but considering that was only three people strong at the time, I knew I would have to be patient." She used her time wisely, putting her hand up for any extra shifts, attending wine tastings and, after covering for a sommelier who called in sick one night, 15 put her on a Wine & Spirit Education Trust training, one of the world's most respected wine courses.

Her patience paid off, and in 2012, Honey landed the much-coveted job in the marketing team. Within a year, aged only 24, she was running their media and international TV campaigns by day and working in the bar by night. "I loved the atmosphere of the restaurant and was in no rush to give that up. I don't remember ever having less than two jobs."

The opening of Sager + Wilde on Hackney Road in 2013 marked a revolutionary moment in London's wine scene. Located in a low-rent area, the bar offered, and still does, a well-curated and reasonably priced wine list, ranging from fine to natural wines, in a totally unpretentious environment. "I've always had a problem with the culture of sommeliers. I've never understood why a product made by farmers is then served up by sommeliers in white coats. Here, all of the staff wore their own clothes and even just that was groundbreaking." The bar would not only be Honey's home for the next 18 months, and the place where her knowledge of wine reached a new level of sophistication, but also home to exacting Londoners looking for a new way to socialise. "The UK doesn't have a huge wine culture because we don't produce any, but Sager + Wilde got young Londoners into wine and got me personally into natural wines."

Natural wines, made with minimal chemical and technological intervention at both the growing and winemaking stages, are different from organic wines (which are made from grapes that are free from artificial chemicals) and biodynamic wines (which are made from grapes grown in accordance with ancient, holistic farming practices). "Natural wines means no sulphur, no filtration, no intervention. These are basically just grapes mushed up and bottled. But, essentially, there is no real definition for natural wines yet—it's a journey." With some scientists claiming that the world's topsoil—which is where the biological soil activity happens—could be lost within 60 years, and that the UK may only have 100 more harvests, Honey made it her mission to know everything there is to know about responsible, biodynamic farming and winemaking.

Honey learned that if she was going to be serious about natural wines, she needed to be in Copenhagen. More specifically, she needed to be working with the king of natural wine, Sune Rosforth, who has been educating the Danes about natural wines—and selling them at wholesale prices—from his canal-side wine shop

Rosforth & Rosforth since 1994. In Copenhagen, Honey's interest morphed into a fully fledged love affair with natural wine. "Natural wines do so well in Denmark for two reasons. Firstly, Danes are ethically wired that way ethics comes before taste for them. Secondly, the natural-wine flavour is so akin to the foods Danes are familiar with, like sauerkraut. So my next challenge was converting Londoners to these new tastes."

Sune is closely associated with NOMA, the two Michelin-starred restaurant that has been No 1 in the The World's 50 Best Restaurants list four times and Copenhagen's greatest pride. He is godfather to the children of its head chef, René Redzepi, and former NOMA sommelier Pontus Elofsson is a partner in his business. Before returning to London, Honey had a three-month stopover working as a sommelier at NOMA's pop-up in Tulum, Mexico.

Back home, she co-founded the restaurant Nuala, with Irish chef Niall Davidson (previously from Chiltern Firehouse) and Fat Duck's Colin McSherry in the kitchen. Honey became a partner through 'sweat equity'. "I might not have put money in, but I earned equity through hard work." It paid off. Her wine list of biodynamic, organic and natural wines was cleverly divided into sections "according to the craziness of the wines' tastes. There are plenty of organic wines that taste of your trusted Malbec or Cabernet. But then there's the crazy shit. With those, you have to forget it's wine. It's a completely new category of drink." She likens it to drinking kombucha for the first time. "If you think you're going to be drinking lemonade, you'll be disappointed."

Her wine list consisted of four sections: 'Tried and True', 'The Classics', 'A Touch out of the Ordinary' and 'Wild Things'. In the words of Jay Rayner, one of London's most admired and feared food critics, "it's a wine list with a map. If you want to experiment, you can. If you want to go vanilla, you can do that, too. Other restaurants should come and study the Nuala wine list to see how it's done." This was a huge feat considering food reviewers are generally quite wary of natural wines. "Sommeliering is formulaic—its rules don't apply to natural wines. So the critics tend to be threatened by them because they're different from everything they've learnt."

Honey left Nuala at the end of the summer of 2018 to start her own company with Nuala's sous-chef Anais Ca Dao Van Manen. BASTARDA is at its core an events company. Its mission is to champion daredevils in the world of food and drink by combining it with design, music and art in a rethink of the eating and drinking experience. "We're the bastard child of hospitality." Its audience may be interested in experiencing design, food and drinks or in simply expanding their entertainment repertoire, and regularly includes some of the city's most respected restaurateurs.

For Honey, the desire to help people on the journey to discover natural wines is two-fold. First and foremost, it's an agricultural mission. But she is also passionate about helping people to discover new tastes. "I'll try anything and I live for that. But most people, although happy to try new food, are more reluctant to try new wines. They don't want to look stupid so they order what they know they like. A good sommelier is going to challenge you but also make you feel amazing."

While BASTARDA aims to create disarming experiences around food, it also wants to let people experience real hospitality. It has collaborated with Empirical Spirit Copenhagen, often dubbed 'the NOMA of booze', with Chef Elizabeth Haigh of famed restaurant Pidgin, and with Kaizen House, the food incubator that is trying to find new ways to improve the hospitality industry.

Honey is also building a global Natural Wine Symposium, bringing together sommeliers, winemakers, agricultural experts, distributors, business owners and policy makers to discuss the things that matter most in the wine industry today: a responsible agriculture, the evolution of taste, social entrepreneurship and how to build a better future for the industry and those that interact with it around the world.

How to get stuff done in London:
You have to be a good person. If you're too strategic, Londoners will see straight through you. If you help someone here, it will always come back to you.

What makes a Londoner?
Londoners are resilient, can absorb a lot and don't switch off even for a minute.

London in a nutshell:
Bravery.

Fernando Laposse

Introducing new, natural and sustainable materials to the design world

Designer Fernando Laposse builds bridges between product design and gastronomy by transforming natural, cheap and often perishable materials into items of high value. His artistic practice ranges from furniture and tableware design to soap, sculpture, performance and video, and challenges patterns of consumption as well as design conventions. "My philosophy often requires a lot of experimentation, relearning of old crafts and hours of manual labour. That's why I identify more as a craftsman than a designer."

Born in Paris and raised in Mexico, Fernando grew up with a painter for a mother and a fourth-generation baker for a father. "As a result, I was always close to food. I remember helping him in the bakery as a child around Christmas time, cracking about 5,000 eggs a day and loving it. But my dad was also a trained architect, so that, coupled with my mum's artistry, meant I was always very sensorially aware." The mix of art, industry and food would become the basis of Fernando's later work.

"The job of a designer is to create desire, but my vision of design was never the feeding of the monster. I wanted to hack it."

At the age of 15, Fernando moved back to Paris before relocating to London to study Product Design at Central Saint Martins five years later. The course was heavily geared towards industry and marketing, with a lot of focus on packaging and digital solutions. It was around the time smart foods were emerging and fast consumption and digital solutions were hyped up, much to Fernando's frustration. "The job of a designer is to create desire, but my vision of design was never the feeding of the monster. I wanted to hack it."

One of his first attempts at that was his luffa project. A member of the cucumber family, the luffa is a very fibrous plant when fully ripened and is often used to make scrubbing sponges. "The brief from Central Saint Martins was to make something with a material from our home country. In Mexico, luffas are a plague; they grow everywhere. So I wanted to make a material that isn't considered valuable, valuable." Fernando used it as a material to make furniture, thereby bringing a bathroom item into the rest of the house. "The plastic sponges that people wash themselves with these days are also referred to as loofahs. The idea that we name something plastic after something natural is so ironic to me." The project taught him that using new materials could be a tool for storytelling.

He applied this inspiration to his graduation project, a machine that makes sugar glassware. He adapted industrial design techniques for using plastic or resin and applied them to sugar instead, pursuing similar levels of finishing, refinement and aesthetics. "It was a combination of kitchen crafts and basic industrial manufacturing: first, I made a lollipop model, then a prototype with a copper mesh holder, and the third and final model was completely made out of sugar. I even designed cocktails especially to go with the glasses, like a sugarless mojito that would get its sweetness from the glass itself. In my mind, it started as a comment on the creation of desire: a one-off item that you could wash down the drain with hot water. Then, it became a business."

At the time, Fernando only had a Mexican passport. One way for him to remain in the UK was to take part in a competition in which he

"How have we become so busy that we don't have time to think about where things come from?"

had to propose a business idea that could grant him a visa. He submitted the 2.0 version of the sugarware machine. "I worked out that we could make about 100 glasses a day. We made little capsules, 3D printed them into moulds. They were hollow and we injected them with alcohol and embellished them with intricate drawings. They were like jewels. So for two years, I made good money making basically only sugar glassware for alcohol brands and event companies. After a while, I felt like I was becoming a glorified caterer. But it was a stepping stone, so I just had to suck it up."

Another chance to experiment with his love for food came when design studio Arabeschi di Latte approached him with an idea for an exhibition called *Nighttime Pantry*. It inspired him to dig into the meaning of 'pantry': a place to make bread, store lard and clean silverware. To represent these different uses, Fernando chose a wooden utensil, pig's fat and a silver spoon to work with. Through an alchemistic process, Fernando made a black soap moulded in the shape of a rock reminiscent of the philosopher's stone, and a blown glass bowl to represent the alchemist's obsession with mercury. "I had been researching how to make mirrors for a while and learnt that one of the ingredients for making a mirror is the same as for making soap: potassium hydroxide, also known as potash, which you can make from ashes. So I burnt the wooden spoon to make ashes, rendered the pig's fat into lard, and dissolved the silver spoon to make silver nitrate." An aesthetic video detailed his elaborate process for the exhibition.

Submerging himself in such ancient practices made Fernando realise how removed humanity has become from the sources of food and tools. "Up until not too long ago, we would buy a whole pig and use every single part: the bones to make glue, the fat for soaps, the meat to eat. So I started going to butcher shops, asking for all the trimmings and made sculptural objects out of soaps. I wanted to create objects that would make people think about this: how have we become so busy that we don't have time to think about where things come from? I felt that everything I had been taught about design had been a distraction from that."

When the Centro de las Artes San Agustín, Latin America's first sustainable and environmentally conscious cultural centre, offered him a three-month residency themed 'first food', Fernando jumped at the chance to return to his native Mexico. The centre is the brainchild of influential Mexican painter and activist Francisco Toledo, and lies in the foothills just outside the UNESCO heritage site of Oaxaca. Fernando decided to focus on corn as the basis for his residency. "It's Mexico's most primal food and the world's first man-made plant. Without corn, we wouldn't have had Aztecs and Mayans, but equally, without man, we wouldn't have corn. This is why for indigenous Mexicans, corn has spiritual meaning."

Fernando immersed himself in the history of corn and learned about how an increasingly globalised world has virtually eliminated the ancient varieties. He researched genetically modified hybrids and the reasons behind the ecological disasters that the post-WWII corn boom has brought to his home country. "I visited parts of Mexico that I remember as extremely fertile land from my childhood, only to find them dried up and covered in rocks. I knew I wanted to come up with an economical solution for these problems."

His experience in turning humble materials into attractive objects, an ability to tell a story and a desire to tackle big issues led him to develop Totomoxtle, named after a word used in many Mexican indigenous dialects for a specific leaf of the corn husk. Totomoxtle is a veneer for interior surfaces and furniture made from these extremely colourful and water-resistant husks. He started working with a group of women, teaching them to carefully cut and peel the husk off the cob, flatiron it and glue it onto a paper-pulp or textile backing. The material is then ready to be cut by hand or lasered into small pieces that are reassembled to create the veneer.

"If we want to be sustainable, we need to move with the cycle of nature."

"Totomoxle is really about the conservation of biodiversity for future food security. If we keep relying on one variety of plants, we'll become incredibly vulnerable. I'm trying to cut through so much of the greenwashing that's going on and make clear that, if we want to be sustainable, we need to move with the cycle of nature."

It is no wonder that when the Citizen M Hotel was looking for a sustainable designer for an installation at the 2018 London Design Festival, it turned to Fernando. The brief was to transform the hotel entrance into a shelter from the urban landscape of East London. Fernando created a cosy lounge area with a huge teddy bear made from sisal, the material once used to make ropes and fishing nets until the arrival of plastics and nylon put an end to it. "I wanted to make people think about the fact that tackling sustainability isn't necessarily about technology and inventing new materials. It is about harnessing indigenous wisdom that has been around for centuries."

Fernando attributes his decision to live in London to the fact that the city allows him to make an impact on the things that matter to him. "Firstly, London is a great base for entrepreneurs. You can still find cheap space here and it's extremely easy to get set up as a sole trader: you fill in a short online from and pay about £20, wait ten days and you're good to go. Compared to other cities, this is such a blessing. Secondly, communication cycles start in London. I'll have more impact in Mexico if I'm successful here."

The project is having far-reaching effects, creating local employment, raising awareness of the issues around the loss of corn varieties and regenerating traditional farming practices. Its success won Fernando the 2017 Future Food Design Award, which highlights innovative designs for sustainable food. It also attracted the attention of the world's biggest corn-seed bank and led to him working with CIMMYT, the International Maize and Wheat Improvement Center, to reintroduce old seeds into Mexican agriculture.

How to get stuff done in London:
Simple as it may sound, you need a healthy dose of pragmatism and to work very hard.

What makes a Londoner?
A Londoner is someone who makes the most of everything.

London in a nutshell:
London is the perfect balance between the US and the EU: it has the entrepreneurial spirit of the States and the bohemian culture of Europe.

Josh Cole

Hard Cock Life, Butt Mitzvah

Breaking down barriers in London's queer nightlife

When Josh Cole first organised a gay hip-hop party called *Hard Cock Life* in an East London cellar bar seven years ago, little did he know that it would turn into one of the most popular club nights in the city.

"I'd always been passionate about hip-hop, but for a long time it felt quite jarring to be listening to that music and be gay." The only place to do that, it seemed, was the urban room at G.A.Y., the most commercial gay club in the country.

"It all started with the attitude of 'Wouldn't it be funny if?' and I focused on what me and my friends would enjoy rather than on what would appeal to the masses." So in November of 2012, Josh rented the cellar of Manero's Bar in Hoxton, with the rather apt capacity of 69. At one point, Josh went outside for a cigarette and the 13-year-old sister of a friend took over the decks. The vibe was celebratory and there was excitement in the air, a feeling that they may have just hit on a big idea.

Soon enough, word got out and Josh needed to find a bigger space. "Finding a venue in London is one of the hardest things about entrepreneurship of any kind. Most venues want you to close around 1 or 2 a.m. and are strict about noise pollution, so finding a perfect fit is tremendously time-consuming and, at times, demoralising." But when the Ace Hotel opened in Shoreditch in 2013, they welcomed Josh with open arms and for four and a half years, *Hard Cock Life* had a happy home there. "Celebrities started coming, and the nights just grew bigger and bigger every time. It's so rare for a club night to survive for that long, but each one honestly still feels fresh and exciting. The moment it doesn't, I'll shut it down and let some new idea take shape."

Six years after that very first night, 800 people gather every few months at a new venue, Hangar in London Fields, for the latest edition. The party attracts an immensely diverse crowd of hip-hop, RnB and rap music lovers—gay, straight and everything in between. It counts many famous faces among its guests but Josh is reluctant to give up the decks to any celebrity guest DJ. "I'm a control freak and I don't really dance—my favourite spot is definitely behind the decks. I'm obsessive about details such as the temperature in the room and sound levels. I just want to give people the best possible experience. I'm not the kind of guy who will get on stage, elaborately welcome people and be the man of the hour."

For Josh, *Hard Cock Life* was always about the desire to create an opportunity for more social inclusion. He wanted to bring queer Londoners together in ways they may not have experienced

> **"We welcome Jews and non-Jews, chosen ones and unchosen ones, boys, chicks and boychicks, plus all those clever enough to have transcended gender."**

before. This mission led him to launch a second venture, *Butt Mitzvah*, London's first-ever queer club night for the Jewish community. It is an immersive party with the tagline '*The ultimate cumming of age party*', and could be described as the punk drunk of gay nightlife. It is aimed first and foremost at Jews but "we welcome Jews and non-Jews, chosen ones and unchosen ones, boys, chicks and boychicks, plus all those clever enough to have transcended gender."

The first night was an overwhelming success, with people queuing around the block of the Glory in Haggerston, East London. "I hated seeing people left out in the cold, but it didn't seem to matter. Everyone was just so curious and excited." It has now moved to a subterranean venue called The Vaults, hidden away in the tunnels under Waterloo Station.

A *Butt Mitzvah* night is structured like a classic Bar or Bat Mitzvah, including a welcome by the family as you enter the venue, the obligatory chocolate fountain, lots of Jewish dancing and a black-tie dress code. The nights start earlier than an average club night would, around 9 p.m. "Jews like to do things early in the night and, at risk of stereotyping, they like to drive." When guests

> "At *Butt Mitzvah* it's often the first time that the fact that someone is gay and the fact they're Jewish are co-existing in the same space."

enter, they are hosted by the Rimmer Family, a parody of a typical North London Jewish family. The characters have their own story lines that are shared in videos posted on the Butt Mitzvah Facebook page. People are strongly encouraged to bring their own families and mums get in for free. "You get an 18-year-old and an 80-year-old bonding in a very camp environment, experiencing the queerness of their loved ones together. It's often the first time that the fact that someone is gay and the fact they're Jewish are co-existing in the same space."

With half the crowd never having been to a Bar or Bat Mitzvah, *Butt Mitzvah* is doing more for assimilation and for Jewish-British relations than any conference could achieve. "As a Jew in Britain you can feel like an outsider: you're white but you're not sharing quite the same identity. You're not there for Christmas and church. And as a gay person in the Jewish community, you can be a bit of an outsider as well. *Butt Mitzvah* tries to bring these two sides of this community together in a joyful experience."

Part of the beauty of *Butt Mitzvah* is the chance for people to meet. "I always thought there were only about ten of us in London but now I realise there's bloody loads of us. I love helping the boys to find nice Jewish husbands."

The nights are popular with Jewish spiritual leaders too: it is rare to find so many young Jewish people together in the same room. Rabbis even take an active part in immersive elements of the event, talking privately with guests if they have a problem and offering spiritual guidance with a reading from the Torah. For rabbis to embrace their communities' queerness sends a strong message to a younger generation of Jewish gays, who have grown up believing that there is a clash between their religion and their sexuality.

The past 12 months have seen a burgeoning of minority club nights, including *Gayspacho*, a Spanish night, and *Humggama*, inspired by Bollywood. "Many of us in Britain are third-, fourth-generation immigrants. These expressions are all ways for us to channel our identity and respond to modern Britain."

How to get stuff done in London:
It's really not about whom you know here. You just need to be organised, determined and communicate your ideas clearly and quickly.

What makes a Londoner?
Londoners are fast-thinking and fast-moving. They're restless.
They aren't judgemental but they are quite self-important. They all have a feeling of self-importance because they believe that they are at the centre of everything. And I guess they are.

London in a nutshell:
It's 'you do you.' London just works.

Martin Usborne and Ann Waldvogel

Hoxton Mini Press, Street London

Putting collectible photobooks on Londoners' bookshelves

It was a series of chance encounters that eventually led Martin Usborne and Ann Waldvogel to launch Hoxton Mini Press, a much-loved independent London publishing house that focuses on telling photography-led stories from London's East End.

At a time when everyone claims publishing is dead and content is moving online, they have managed to build a strong fan base of photography book lovers, with titles that centre on people who live and work in East London. As Martin puts it, "if we had done a book about Canada and then about Mexico, we would just be another publisher. But the fact that we focus on this rich, local terrain that is full of creative people means that we have managed to build a community that pulls us along." Ann adds: "We started publishing books on this area when it was going through a transformative time and the specificity of our subjects' worlds is something a lot of people can really connect with."

It all started when photographer Martin met a dishevelled older man named Joseph Markovitch in Hoxton Square, East London. Thinking he was homeless and drunk, Martin took a picture of him and was convinced it would be an award-winning shot but that would be the end of it. Instead, a five-year friendship ensued between the two men.

"Once I didn't have a goal for my relationship with Joseph, the whole relationship became much more authentic. He wanted to show me his London and I wanted to photograph it."

Eventually Martin decided to exhibit his work and to create a catalogue for it. He downloaded an illegal copy of InDesign and in one night, taught himself the software, laid the book out and sent it to the printers.

With *I've lived in East London for 85.5 years*, Martin had published his first book. "I think deep down, all photographers want to make a book. And at that time, in 2010, there was a real fetishism around photo books. People were obsessed with getting published. In our increasingly virtual world, there is something so special about a physical book, about committing an idea to paper." The book sold out quickly and there was demand for a second print run. Martin called it *I've lived in East London for 86.5 years*.

It was not until five years later that Martin, in a beautiful case of serendipity, met gallerist Ann in almost the exact same spot he had met Joseph. "I'd worked in different galleries in New York and London and had become somewhat disillusioned with the art world," Ann remembers. They decided to make books together, involve local photographers and stay focused on the fertile terrain of East London—as business partners and, later, as a married couple with a daughter. They both disliked how niche, highbrow, exclusive and expensive photobooks were and wanted to make something small, affordable and "God forbid, something with humour," Martin says. Ann adds: "Martin and I realised we had an opportunity to create a series of books that would make photography accessible to more people."

As the capital of a book-loving country like the UK, London is a relatively easy place to operate in for a publisher. According to the Publishers Association, UK book sales reached £5.7 billion in 2017 and income from UK book sales was up 5% in 2018, with a 31% rise in sales of hardback books. Many independent publishers thrive here, such as No Brow, Penned in the Margins and Portobello Books.

> "In our increasingly virtual world, there is something so special about a physical book, about committing an idea to paper."

"We never wanted to grow into a huge company. We've always wanted to be the publishing equivalent of 'buying local': use local photographers to tell local stories for local people," Martin explains. But Hoxton Mini Press' influence is undeniable: their books sell internationally, copycats are mushrooming and they're working on a series of books with Penguin Books. "It seems we have created an interesting, lasting document of a community: a durable memory of what East London was like at a certain moment in time. And people are still longing for keepsakes," says Ann.

"We've always wanted to be the publishing equivalent of 'buying local'."

Hoxton Mini Press is unusual as there are not many publishing houses out there that have a strong brand; usually they rely on the strength of their title or author. Martin remarks: "Smaller books seems to be gaining popularity and our signature linen spine has become a more common sight in bookshops. But we can't do books on East London forever. So the question is, how do we maintain our brand but still remain successful?"

They now have about 50 titles under their belt, including popular publications such as *Drivers in the 1980s* by Chris Dorley-Brown, which documents drivers stuck in traffic jams in East London, and *One Day Young*, in which Jenny Lewis depicts women with their newborns, all photographed within 24 hours of birth. "Our books connect with people because they display topics people can have a relationship with," Ann explains. Furthermore, they are affordable and have opened up a new demographic for photography books.

The duo has branched out and now also runs Street London, an annual street photography festival, together with Nick Turpin from iN-PUBLIC and Jason Reed from Observe Collective, both street photographers collectives. The festival launched in Paris a few years ago, had a New York stint and now lives in London. It explores street photography in the widest sense, be it photojournalism, art photography or portraiture, and features panel discussions, keynote speeches and street parties. The two-day event challenges the preconception that street photography is exclusively for, and of, a middle-class, white, elitist group of people by gathering a diverse group of backgrounds, ages, genders and identities. In Martin's words, the festival's mission is to "help photographers develop their own voice within street photography," against the backdrop of one of the world's most photographable cities.

How to get stuff done in London:

Martin: You need people to buy into your vision and tap into a community. If you get it right, it won't be you pulling a community along; the community will be pulling you along.

What makes a Londoner?

Ann: Someone who has managed to integrate themselves into the city and has built a community.

Martin: A vibrancy and colour mixed with a very English dose of irony and good nature.

London in a nutshell:

Ann: It's a place made up of lots of close-knit communities.

Petra Barran

Kerb

Making the streets of London taste better

To Petra Barran, street food is a necessary service to any city, an expression of the complexity of its cultures and a means to make those tangible and accessible to the masses. "Street food allows anyone to taste the pulse of a city."

As the founder of Kerb, an organisation that brings together the city's best street food traders and organises food markets and corporate events, Petra wants to make eating well on the streets of London a normal experience. Choosing street food over other food options is an increasingly popular choice for Londoners and tourists alike. "These days we are so guided by Google and Tripadvisor and pretty much always know where we need to go and what we are getting. I want to create spaces for spontaneity and food markets offer a sense of discovery and autonomy, whilst empowering you to know exactly where your money is going."

"The empire is part of the reason Londoners have an appetite for experimentation. We will try anything."

Describing restaurants as exclusive by nature, Petra believes her markets offer another way to eat out. "Firstly, as a customer, you need to have been made aware of a particular restaurant in order for you to even know that you want to eat there. Then once you're there, the cost can be prohibitive or you might not feel welcome. As a restaurateur, you are wasting money on rent, furniture, lighting and staff, and for many fantastic chefs, that is just not affordable."

Kerb has disrupted how professionals in the city eat, feeding people lunch in eight locations across the city, and has also challenged the catering world. It connects independent food traders directly with corporates and presents an appealing alternative to the familiar soggy-sandwich-and-packet-of-crisps formula that so many companies have relied on for too long. "Food culture in London has grown enormously in confidence. I have always been fascinated by the British Empire and what it has meant for our culinary experiences. The empire is part of the reason Londoners have an appetite for experimentation. We will try anything."

In her mid twenties, Petra started working on yachts in Italy, looking after guests, cleaning, bartending, setting tables, doing laundry, making beds, arranging flowers, you name it. By the age of 27, she hated what she was doing. "I felt like I needed the universe to help me find my purpose. One night I turned on the TV and decided that the first channel I would come to would give me a sign. It was a Catholic service programme. To me that meant I needed to have faith. I decided the second channel would tell me what I had to have faith in. It was a cooking show. And it was like everything fell into place at that moment. I had grown up around food and loved food. I just hadn't thought about making it a career."

Petra moved back to London to try to get into the food business. She got a job with well-known British entrepreneur, politician and farmer Wilfred Emmanuel-Jones, also known as 'The Black Farmer', who founded a range of food products including ham, sausages, chicken and sauces. "I was flogging sausages for him all over the West Country. I enjoyed being on the road and selling food, but hated having to be in the office. I knew that job wasn't my calling. Then one evening I was at my cousin's house on Portobello Road and she

was telling me about how much money all the food stalls on Portobello Road were making. And we figured out the one thing the market didn't have: a chocolate stall. A new idea was born that night."

She applied to Kensington and Chelsea Council for a pitch and was thirteenth on the waiting list. "When you initially have an idea like that, you are so full of optimism and think everything is going to fall into place. But then reality kicks in. I was told someone basically needed to die before I would get a pitch. But I was hell-bent on this idea and didn't give up." She quit her Black Farmer job and found another at the best chocolate shop in London, Pierre Marcolini, learning everything there was to learn about chocolate. She decided that it would take too long to get a stall and bought an old ice-cream van instead. "There I was, with a big idea and a van, and I didn't know anything about where I could trade or how to run a business. I was incredibly stressed out. For days on end, I would just drive around and sell ice cream. I was chased away by police more than once. My business definitely wasn't well thought out."

She did get a pitch on Portobello Market, but at the wrong end. "All anyone ever wanted was a hot dog and a cup of tea. So I started making cups of tea and would take home £60 on a 12-hour day. It was so crushing but I couldn't stop; I was in the middle of the war zone of making my idea real."

Eventually, she landed a pitch in East London's Brick Lane and took home £500 on day one. She had found the right demographic and from there was invited to pitch up at festivals and other markets. But Petra had always suffered from itchy feet. It was 2008 and she decided to take her van on the road around Britain, offering a chocolate pudding in return for a bed for the night. "People were giving up their bedrooms, doing my laundry and cooking me roast dinners. It's unbelievable what people would do for chocolate."

Early in 2009, she found herself in Ireland and confronted with a major setback. After paying a festival organiser a deposit of £1,500 for a pitch, she lost the money when the organisation went into liquidation. "I realised that as street food traders, we were so vulnerable to these kinds of scenarios. I knew we had to band together and combine our powers."

"There's always been a strong sense of community in the street food scene. It's you against the elements."

She founded Eat Street, a traders' collective, with a friend: its mission was to drive British street food forward. "It was a hobby at first that would allow us to become more visible together and demonstrate the creativity going on in the London streets. There's always been a strong sense of community in the street food scene. It's you against the elements, rolling up your sleeves and getting on with it. Eat Street capitalised on that truth."

In October of 2011, the developers working on the expansion and regeneration of King's Cross contacted Petra to ask her to help them activate the area and change the public's perception of it as a hotbed of drugs and prostitution. "That's when I knew I could turn Eat Street into a business. But I also knew it wouldn't work in the way we were set up at the time. I broke with

> "The combination of meat and wheat still does so well but the demand for vegan food has been explosive."

my then associates and went against everyone's advice and changed the name to Kerb."
Since then, Kerb has built an eco-system for street food traders across the capital. inKERBator is a three-month incubator programme of mentoring, consultancy and practical experience. While they are incubating, businesses get pitches on the incubator markets of King's Cross and West India Quay, and once they graduate, they move on to the busier markets of Canary Wharf and join Kerb's corporate catering list.

inKerbator guides businesses on their journey from start-up to trader to mentor and even restaurateur, if that is what they want. "In the early days, opening a street food stall was the first step on your path to opening a restaurant, whereas now, increasingly, street food stalls are big businesses in their own right."

Today, Kerb offers anything from Filipino curries and Palestinian wraps to vegan Thai and Mexican tacos. "It's been incredible to watch the growth of flavours and ideas, but also to witness how the classics still have such a strong following. The combination of meat and wheat still does so well but the demand for vegan food has been explosive. Ultimately though, the success of any food stall depends on who runs it. People can taste the love in your food and the devil is in the detail."

The London street food scene has changed unrecognisably over the past decade and has become more organised, professional and extensive. "In a way, it seems less exciting now, but there are constantly new opportunities popping up. Mid 2019 we are launching a giant food hall in Covent Garden with a twenty-year lease. It's a daunting prospect and an entirely new proposition for us, but it brings us just that one step closer to making great food accessible to everyone."

How to get stuff done in London:
You need a big vision, charm, persistence and resilience.

What makes a Londoner?
Being at ease with being surrounded by lots of different people at the same time and having a sense of humour about everything.

London in a nutshell:
London is there for the taking.

Catherine Borowski and Lee Baker

SKIP Gallery

Creating alternative spaces for art

Slide exits out of top skip from end or side.

Scaffold frame twice as deep as skip to allow for visitor's passage (so to speak)

Painted scaff &/or LEDs &/or mesh

12M

Stairs lead to next level etc

Closed skip but with open ends

Scaffold stairs leading into first skip

20M

4M

4 metres

Visitors weave in and out of each skip

Stairs inside both ends of each skip for entrance & exits

skip width 2 metres

2M

Height 2M

There is some disagreement between Catherine and Lee about how their SKIP Gallery venture initially came about. What they are clear about, though, is what it is trying to achieve: SKIP Gallery offers an alternative route for both makers and lovers of art to create and experience art. As partners in business as well as in life, the duo have created a new type of mobile gallery space that hosts exhibitions of commissioned work by different artists in an eight-yard skip, specially modified and kitted out, and installed in different locations across London. Previous collaborators have included David Shrigley, Richard Woods, Gavin Turk and Ben Eine, and for 2019, Catherine and Lee plan a skip pavilion that will bring together lesser- and better-known artists in a guided, multi-layered gallery experience.

As a multi-disciplinary artist, Lee's work spans music composition for TV shows, painting and set design. He's influenced by Japanese culture, creating large-format paintings and installations that explore its historical imagery and its influence on the West. He is also the creative director of Produce UK, a place-making agency founded by Catherine in 2004 which works with developers and cities to turn non-places into spaces. Catherine's expertise lies in creating destinations: "I'm not quite a maker of art as such, but to me, SKIP Gallery is my art: it's a roving, evolving art concept that not only collaborates with other artists, but is an artwork in its own right."

In her version of the story of SKIP's birth, it was September 2016 and she was exploring having a presence at London's biggest annual art fair, Frieze, which attracts thousands of art dealers, critics and buyers from around the world. She started looking for a space to hire, but everything had either been booked up a year in advance or was unaffordable. "It dawned on me exactly how prohibitive these events are for artists. Unless you're represented by a gallery or have an agent, there's no in. So I decided to create a disruptive, alternative space and really try to shove it in people's faces during Frieze."

She picked a skip as the medium of choice. "The benefits of a skip are that you can just stick it on the road without people knowing it's an artwork, set it up really quickly and roll it away before the council or police can take offence to it. I also loved the idea that people could get inside it easily and be alone in it."

From Lee's perspective, it was a skip that sat outside his apartment for many months that inspired Catherine to consider it as a possible art space. "We will forever argue about what sparked the idea. What matters is how we complement each other. My love of art is far more aesthetic. Catherine's is much more conceptual. But it's our combined sensibility that has made SKIP the success it is."

To Catherine and Lee, skip art is true street art and the skip itself is a conceptual art piece rather than simply an exhibition space. SKIP Gallery provides a means for them to push back the boundaries of their own art and allows them to put their money where their mouth is. In their words, "SKIP itself is an emerging artist."

"The benefits of a skip are that you can just stick it on the road without people knowing it's an artwork, set it up really quickly and roll it away before the council or police can take offence to it."

Their first-ever SKIP was a memorial for Catherine's mother, who had converted to Islam when Catherine was 10. She died unexpectedly in Mecca after completing her Umrah pilgrimage there. It came as a huge shock to Catherine and, mentally and physically unable to go to the burial, she decided to hold her own memorial in the way she knew best: by turning it into an artistic experience. The format was a SKIP exhibition titled *Na I Don't Want None of That Again*. Guests were asked to dive into the skip one by one to watch a dancer move to a musical composition by Lee that took the last note of Catherine's mother's favourite song, Amy Winehouse's *Valerie*, stretched it out for five minutes and entwined it with Edith Piaf's *Je Ne Regrette Rien*. Lee describes it as "almost a symbol for how London has changed, with elements of Islam, British culture and contemporary art all mixed in together to create a highly personal experience that everyone somehow seemed to connect with."

For the second show, Lee was keen to work with Turner-nominated artist David Shrigley, known for his satirical comments on the mundane and for his 2016 sculpture of the thumbs up on Trafalgar Square's Fourth Plinth. When Lee heard that David had moved into a house around the corner from him, he decided to simply slip a note under his door, tell him about SKIP and hope for the best. David was immediately sold on the idea and, a few months later, the Shrigley skip show *Look At This* opened on Hoxton Square. It is because of its location, says Catherine, that the show attracted attention from a great diversity of people. "We had a bunch of binmen look at it and think it was hilarious. It truly became art for the people."

Next came a collaboration with renowned street artist Ben Eine in which he created a live graffiti piece inside a skip that was simultaneously hosting live drawing classes. There have been many more skips since then, including a month-long Richard Woods skip show, *Upgrade*, in June 2018. Part of the London Festival of Architecture, the exhibition dealt with the issues surrounding housing and urban regeneration. While filling a skip one day with leftover materials from a previous show, Richard was struck by the potency of the scene: fragments of window and chimney poking out of a skip. When Lee emailed him and introduced the SKIP project, they quickly realised they had both stumbled on the same idea.

The reaction to SKIP has been overwhelmingly positive. "There is something about a skip that immediately strikes a chord with people," Lee explains. "Everyone has a relationship to a skip or some kind of memory of one: diving in them as kids or students, being irritated by them because they're blocking your driveway, having lost something in it."

"We just want to encourage artists to make their vision happen in any way they can."

But it's not just the conceptual side that resonates with people. The rigidity of the art industry, with its lengthy funding processes, monopolising institutions and the increasing pressure for art to be profitable, puts up too many barriers for artists. "A lot of the urban art these days is sponsored by corporations or developers who simply want to sell product or real estate, and the experience of that art becomes very two-dimensional," Catherine explains. "And art institutions like Tate are now almost a singularity: they provide incredible shows but equally,

they suck up the majority of the funding out there. They operate within the confines of their universe. You need to be in the know to share in it. We want to offer a diversity of art that people stumble upon, even those people who know nothing about art."

Lee adds that "when you go for art council funding, you have to justify every step of the way and your idea has to have a pathway to public good. It also needs to have Instagram potential and be so visual that it can lose its subtlety. Historically, art was just about pure expression. In David Shrigley's words, 'Art is thought made real.' But now the many conditions put upon artists have made participation in art really very hard."

SKIP will collaborate with Selfridge's in March 2019 on the month-long show *Like It Or Lump It*. A skip outside the shop's new Duke Street entrance will host a series of sculptures, installations and performances by London artists Sarah Maple, Richard Woods and Paul Kindersley, who was part of the 2018 Hayward Gallery show *DRAG: Self Portraits and Body Politics*. Contemporary visual artist Claire Pearce will take over one of Selfridge's changing rooms. The subjects tackled will range from identity, body politics and gender to ecology, mental health, authenticity, cultural history, cosmetics and ridiculousness.

For Catherine, the collaboration is a marker of positive change: "There is an increasing desire to do things differently. In that respect, we aren't unique. We just want to encourage artists to go for it: to take over a space and to make their vision happen in any way they can."

How to get stuff done in London:
Catherine: You need a lot of gusto and patience.

Lee: In London it's very much "You don't ask, you don't get."

What makes a Londoner?
Lee: A Londoner will always defend London to the death.

London in a nutshell:
Catherine: London is the city of endless opportunity.

Lee: It's the only place on earth where you can get whatever you want and walk for hours without hitting a boring spot.

Lewin Chalkley, Matt Harper, and Sam Humpheson

Look Mum No Hands

Normalising cycling in the city

Any Londoner who enjoys a decent cup of coffee will have heard of, and more likely have visited, Look Mum No Hands. And Londoners who are into cycling will make a point of telling you to check it out.

As a cafe slash bike repair shop slash art gallery and event space, Look Mum No Hands launched in 2010 to overwhelming success. While its founders Matt Harper, Sam Humpheson and Lewin Chalkley have very different professional backgrounds, what they have in common is a deep passion for everything bike-related. "We had a vision. We wanted to create a destination for people to celebrate cycling culture in whatever form it takes: from racing and mountain biking to commuting on your Brompton," Sam explains. "A place we wished existed," adds Matt.

A philosophy and law graduate, Matt ended up unhappily working in banking. Sam majored in biology but found a job as a bike mechanic as soon as he completed his degree. "I'd been tinkering with bikes since I was little and that's how I learned. There's no uni for bike fixers!" Lewin had built a career in hospitality, spending five years working for sandwich shop chain Pret à Manger and running an Oxfam cafe. Around 2007, he took a job at Coffee and Crayons, a coffee shop that combined kids' craft activities with hot drinks and cake, and one of London's first 'combination cafes'.

In 2009, Matt was made redundant from the job he hated, and the time felt right for the three friends to rethink their lives and try to make a living from their passion. "We were such biking fanboys," Matt explains. "At that time, there was nowhere in London where you could watch the Tour de France or Paris Roubaix and really celebrate the sport." The trio opened Look Mum No Hands in 2010 and "from the day it opened, people just bought stuff, brought in their bikes and drank coffees, and we turned a profit in year one. And thank God we did, because quite naively, we didn't have any sort of back-up plan," Lewin explains.

There were a few trends in their favour that created fertile ground for their business. Firstly, cycling in general, and fixed-wheel bikes in particular, were all the rage in the late noughties. As Lewin puts it: "It was so fashionable to ride a bike in London and the epicentre of that hype was Hackney, where we lived." Secondly, the city was witnessing a third wave of coffee mania with people becoming obsessed with high-quality coffees and expecting well-trained baristas to pour their morning brews.

"People enjoy the theatre of the workshop."

"So London was in a cycling and coffee craze. But we wanted to ensure we appealed to people who weren't obsessed with cycling too, and get the balance right between being a repair shop and a cafe." Matt clarifies: "People are very happy having their bikes fixed whilst they're sipping a great cup of coffee in a fun cafe. They enjoy the theatre of the workshop. But no one wants to have a coffee in their bike repair shop." In 2012, cycling became even more popular in London with the Olympics, which turned the city into a sports fanatics' paradise, and in the same year, Bradley Wiggins became the first-ever Brit to win the Tour de France. "That was huge for us, with the cafe overflowing with people watching, and film crews from all over the world recording Londoners celebrating our hero."

But not everything about launching Look Mum No Hands was smooth running. Picking a name turned out to be the hardest decision. "It took so long, we almost despaired. We even used the online collaboration tool Google Wave for help, but then one late night, Sam came up with Look Mum No Hands. "It seemed to perfectly embrace our playful nature. We wanted to ensure we were inclusive and offered respite from the snobbishness of a lot of the cycling and coffee lovers," Lewin explains.

The second-biggest challenge was to find a venue, a common problem for many London entrepreneurs. When their current location on Old Street became available, everyone advised them against taking it. "It was along a dead stretch, in between Farringdon and Shoreditch, but at least there were a lot of residents around," Matt remembers. "And the venue was perfect: it was derelict but had once been an organic cafe called A Quiet Revolution, and they left some cool little features behind that we still use today."

Since it had previously been a cafe, there was infrastructure in place, something that usually takes up the majority of the budget. They invested £12,000 each and bought all the equipment second-hand. "We still have a fridge today that we bought in 2010 for £50. It might look like shit but it still works a treat." They have never sought investment from outsiders and are fully independent to this day.

Over the past nine years, they have made mistakes and learned from them. In 2013, they opened a second location in Hackney but were evicted after only two years. However, their third location, in Whitechapel, is still going strong and turning a profit after just two years. "These other ventures have made us realise how lucky we were the first time around, so we will think very carefully about opening another location or starting something new," says Lewin. Today, 65-70% of Look Mum No Hands' profits come from selling food and drinks, and the rest from merchandise, workshops and repairs. Their coffee is sourced from local roasters Square Miles, cakes come from nearby bakeries, the beer is brewed locally and all the food is freshly prepared daily.

Look Mum No Hands has made access to cycling culture equitable and removed the aura of snobbery from artisanal coffee drinking. The cafe's public is proof of that—a mix of freelancers, young creatives, business people, cycling fanatics and retired locals—as is the volume of similar cafes that have popped up around the city in the last five years.

Although investment in cycling in London is still relatively low, about £17 per person, an ambitious target has been set of 1.5 million cycle journeys per day by 2025. But despite more bike lanes, a cycling super highway between Westminster and Blackfriars, subsidised cycling schemes (where you benefit from a tax break for cycling to work) and a shared bike programme that Londoners refer to as 'Boris Bikes' (named after the Conservative Party mayor who implemented it in 2010), a shift in culture remains essential. "In cities like Amsterdam and Copenhagen, cycling is fully integrated in the culture," Sam points out. "Those cities don't just have adapted infrastructures: the attitude of the drivers is different, too. Here, it's not like drivers are actively out to kill you, but they certainly don't try that hard not to. The city of London has great aspirations, but if it wants to achieve that culture shift, it's going to have to get radical and remove private cars from the road. And that's going to upset a lot of people."

But London is slowly experiencing much-needed change. According to the City of London 2018 *Traffic in the City* report, cycling is now the most popular form of rush-hour transport on London streets and the number of people on bikes has quadrupled over the past 20 years. "We are helping in our own way by normalising cycling and making clear to people that anyone on a bike is, in fact, a cyclist, even without the fluorescent jacket, the double lock, the air filter, the protective clothing and the helmet. When cycling is properly integrated into the infrastructure, you don't need all that."

look mum no hands!

THE CLASSICS THE GIRO

Coffee Food Beer
Eat in or takeaway

How to get stuff done in London:

Lewin: You don't just need a great idea; you need the tenacity to make it into a reality too.

Sam: And you need great timing.

What makes a Londoner?

Matt: To me, anyone who lives in London is a Londoner.

Sam: Just like there are so many different types of cyclists, there are countless types of Londoners. It's impossible to pigeonhole us.

London in a nutshell:

Matt: It's a melting pot of people, villages and atmospheres.

Lewin: London is rich: in culture, in people, in variety, in tastes, smells, experiences and opportunities.

Charlie May

Blurring gender norms in fashion

From her North London home, Charlie May runs an independent, contemporary, unisex fashion brand. Seven years down the road, she's carved out a business model that challenges the conventions of the fashion industry: from production and distribution to style and marketing. *Vogue*, *POP*, *l'Officiel* and *AnOther Magazine* are among her fans, as are the men and women who value style and comfort equally.

> "My clothes are made for daily life. They're meant to be worn until they fall apart."

"I see myself more as working in style than fashion. I have a certain aesthetic but I'm not that interested in trends," Charlie explains. Her clothes are approachable and modern, a blend of chic and cosy, and effortlessly take you from the office to a night out. "My clothes are made for daily life. They're meant to be worn until they fall apart, not just to be taken out of the closet once in a blue moon."

Raised in a family of makers—both her mother and grandmother were seamstresses—Charlie was always messing around with the family sewing machine, adapting and upgrading her clothes to make them unique. She went on to study fashion design at Bristol's University of the West of England, where she learned construction and pattern cutting. Seeking inspiration, she immersed herself in fashion blogs: "I saw a lot of blogs out there but nothing was speaking to me." So she decided to write her own. Although *Girl à la Mode* started out as a platform to collect her design influences, it gradually turned into a more personal blog, recounting her travels and daily life.

It was 2008 and the blogger scene was exploding: bloggers were given front-row seats at the Dolce & Gabbana and Versace shows. "I found myself, as one of the only UK bloggers at the time, being interviewed for magazines and invited to openings. It gave me an influential network of PR professionals, stylists, models, which were instrumental to my later success. When I finally moved to London and started my own label, those were the people that helped me to access free venues, drinks sponsors, you name it."

During her studies, Charlie interned for knitwear designer Louise Goldin. After graduation and her move to London in 2010, she had a one-year tenure with Thomas Tait. When recession hit, he had to let her go. She decided to take a gamble and start her own label, the eponymous Charlie May. "I knew I wouldn't be making money initially, but at least I wouldn't *not* be making money for myself, instead of working for someone else not making money!"

Her first collection was a capsule of ten looks for Spring/Summer of 2012 (SS12), which she produced in her living room while working in sales to pay the bills. "Initially, I was really influenced by Belgian designers Ann Demeulemeester and Haider Ackermann. Then I got more interested in hip-hop and oversized fits, but wanted to imagine that style through a minimalist lens."

She had to wait until her third season to be picked up by stockists. "I didn't know what I was doing at the start: what a line sheet was or how they were supposed to buy stuff off me. I was still making all the pieces myself."

Charlie really came into her own with AW15 [the 2015 Autumn/Winter collection]. She challenged fashion convention by launching her line with a live lookbook shoot. "Being able to show people your clothes and also lift the lid on how our

marketing is usually created was exhilarating." By this time she had a few Japanese stockists, and this led to a change in the way she thought about her business. "When I first started selling to Japan, the Japanese were so shocked that I was still working with hand-drawn patterns. Everything there was already made with machines." By focusing exclusively on denim and knitwear, she is able to create everything using CAD and send technical drawings to clients in far-flung corners of the world who then machine-print them. "Draping and technical sketching is less and less part of the fashion industry now, which alleviates a lot of man hours. And now that I don't need cutting machines and room for huge industrial patterns, I am much more flexible in where I work, too."

Charlie has basically eschewed the wholesale model in favour of a direct-to-consumer one. "The problem with wholesale is that everything is on consignment and sale or return." She tells the story of two high-street stockists who placed huge orders one year, only to return half of the items. "One of those stockists had bought all of my wool pieces and retailed them during the hottest weeks of August. When the collection hadn't sold in three weeks, they returned it to me. That experience nearly bankrupted me. It was a turning point."

From that moment on, Charlie began to push the direct-to-consumer channel more aggressively. "I present my pieces in an authentic, unfiltered street style, worn by either myself or my friends, really showing how people would wear them. People don't wear head-to-toe designer: they mix it with adidas and sportswear and that's the vision I sell. And it works. When I post a piece, it sells." She still fills the orders from her website herself.

In the early days, Charlie was producing collections six months in advance, releasing the spring/summer collection in January and autumn/winter in August. Now she has the freedom to release clothes when she feels people want them. "When people need a coat in January, it's sale season. So now I release things when people need them and it cuts my lead time down to four weeks. It takes you out of that hamster wheel of hell of having to design for each season." Working this way also helps her to reduce the environmental impact of her business. "I only make what I need and what people want. I never have excess stock. Brands need to put more emphasis on their direct-to-consumer model. You can't rely on a wholesale market anymore; any stockist can drop you at any time. The stockists aren't on your side, the people are. And people love finding something on Instagram that they can't find in a physical store."

The only time Charlie works with wholesale is when she collaborates with a retailer to create a one-off collection. Her latest exclusive line is with global luxury fashion brand Lane Crawford, based in Hong Kong and China. "Stores want exclusives from brands that customers can't find anywhere else. I give them that and in return they buy a minimal order and do a huge PR campaign. It works well for both parties."

In the autumn of 2017, Charlie launched her menswear line and experimented with making the same pieces for the men's and women's collections. But stockists were not picking it up, citing as their reason that men were already buying her women's collection anyway. "Not what I wanted to hear at the time, but it inspired me to create my first-ever fully unisex collection in

"You can't rely on a wholesale market anymore. The stockists aren't on your side, the people are."

"When you dress for yourself and you feel comfortable, that's when real confidence shines through. And that's very hot."

September of 2018, designed and fitted to work for both. It sold out in a month. It shows you where fashion is going. One of my stockists in Hong Kong is planning to reorganise their entire store so there are no longer men's and women's sections."

Essentially, her goal is to make men and women more comfortable and active, and able to wear the clothes they lounge around in at home on the street as well. "You shouldn't have to substitute comfort for style. For too long, women have been taught to dress for others, not for themselves. We all know that feeling of wearing something we think is expected, that's beautiful and appropriate but totally uncomfortable. But when you dress for yourself and you do feel comfortable, that's when real confidence shines through and that's very hot."

How to get stuff done in London:
London is an easy city to make things happen in: it's heaving with creative people, all wanting to collaborate, and it has a relatively small, close-knit fashion scene.

What makes a Londoner?
We all have a great work ethic but are laid back at the same time.

London in a nutshell:
London is cool and creative and moves at the speed of light. Things happen here.

Maxime Plescia-Büchi

Sang Bleu, TTTism

Injecting the art of tattooing with new cultural relevance

There are parts of London where it can be difficult to find someone who has not been tattooed. That is particularly true in Hackney and that, in part, is down to Maxime Plescia-Büchi.

His Sang Bleu tattoo studio in Dalston is open seven days a week and welcomes a constant stream of people wanting to adorn their bodies with ink. He is not cheap, but ask anyone in London by whom they would love to be tattooed and Maxime's name comes up more often than not. Even Kanye West has been under Maxime's needle, when he created a tattoo to honour Kanye's daughter's and mother's birthdays. It was a collaboration 18 months in the making, but other sessions are more impromptu as the studio welcomes walk-ins and is not pretentious about who or what they work on. "I love the idea of allowing someone to just walk in. It reminds me of why I fell in love with tattooing in the first place. And if someone wants an Arsenal logo on their chest, I'll do it. Ultimately, what they come for is their affinity to our vision of independence and non-conformity, not our particular style of tattoos."

Sang Bleu started as a magazine in 2005, covering art, fashion, photography and the growing subcultures of tattoos, body manipulations and fetish. "I created this magazine because it was something I wanted to see that didn't exist. I wanted the lifestyle me and my friends had and were interested in to be represented." In 2015, Maxime launched another magazine called *TTTism*, which focuses on the past, present and future of tattoo culture. It talks about its tradition and history but also the innovations that lie ahead. "You might think the last thing the world needs is another tattoo magazine, but I believe there's a desire for curated, sensorial content that you can keep going back to and archive."

After Maxime had moved to London from his native Lausanne via Paris, he worked at a design agency and in magazines, so the format of a printed product feels natural to him. "I grew up always being visually stimulated. My parents had an appreciation for culture and took me to see modern art and introduced me to literature. Growing up in Switzerland, it felt like cultural impulses were everywhere." Later, his interests extended to hip-hop, fashion, mysticism, skateboarding and typography but also science and psychology, which became the subjects of his university degree. Subsequent to that came tattoos. "To me, tattoo art is still the purest cultural expression. Everything else has been claimed and gentrified." A nod to blue blood (and ink), the name Sang Bleu is a tribute to the nobility of tattoo art.

"To me, tattoo art is still the purest cultural expression. Everything else has been claimed and gentrified."

It was the renowned tattoo artist Filip Leu—of the famous Leu family—who gave Maxime his first tattoo: a full back piece and sleeve. Filip was taught by his father, Felix, during a nomadic childhood that took Filip to India, Japan and Africa. His travels influenced his later distinctive style, which made him a household name in the tattoo world. Filip saw something in Maxime and offered him an apprenticeship in his native Switzerland. "It took me a few years to take him up on it because I was already in London and had many things going on. But about four to five years after he initially made the offer, I called him to say I was ready." Filip showed

"There isn't a tattoo university you can go to. It's an oral tradition."

Maxime the ropes and, in many ways, helped him to discover his vocation. "It was an incredibly humbling experience for me. I was already a semi-established art director by that time, so going back to sweeping floors wasn't easy. But a year into my apprenticeship, I touched the tattoo machine for the first time and I knew I was born for it."

Apprenticing with Leu was apprenticing with the entire Leu family. "There isn't a tattoo university you can go to, so you learn from a community of tattooists. It's an oral tradition and although the techniques are getting easier as the technology gets more advanced, learning is an intense and humbling experience. It would just take one big corporation to simplify the technique and crack the code and this whole thing would blow up."

A recent study revealed that up to 40% of Britons have at least one tattoo, with women 8% more likely to have inked their bodies than men. A similar study showed increasingly tolerant attitudes towards tattooed professionals across the UK. "Despite all that, the evolution of tattooing in London is slower than in many other places, exactly because London has a tradition in it. For a long time, tattoos were associated with the working classes here, and you can sense that that association still lingers in people's minds." According to Maxime, Londoners are also less willing to spend money on their tattoos. "Tattoos are affordable if you really want them. Even the craziest tattoo won't be more expensive than any other luxury people feel comfortable spending money on. It's for life, so it's definitely not something you want to economise on."

When describing the slow but steady move of tattoo art into the mainstream, Maxime describes it as a mentality shift like any other. "It's part of the same progression that's behind plastic surgery or transgenderism. And it's all a matter of timeline. *Easy Rider* was a tipping point in the glamorisation of the outlaw. If you bought a Harley Davidson in the 1980s, you were sending a clear message about the subculture you belonged to. These days, every high-street chain is selling biker jackets. We're not quite there yet with tattooing, but soon any affiliation between tattoos and prisoners, sailors or gangs will have disappeared."

Today, Sang Bleu is home to far more than tattoos. It has grown into a multi-disciplinary creative space that is also a publishing house, a creative agency and a fashion label with two separate lines of clothing, covering three locations: London, Zurich and Los Angeles. "Tattoo shops aren't formulaic. I'm not interested in building a franchise model. I just want to set up the stage and have each location build its own story. It's a matter of finding the right people. What I look for are good, honest people. You can teach someone the art of tattooing, but you can't teach someone to be decent. When you work in a place like this, you spend a lot of time in close proximity with your colleagues, so they need to be people I'm interested in getting to know personally."

Sang Bleu is also a digital platform that, by reflecting contemporary culture, "seeks to understand and represent modern reality through the unique visions of today's artists." Ultimately, it is the headquarters for Maxime's vision. "It's so fulfilling seeing everything I've worked on for years find this home. Sang Bleu is our Gesamtkunstwerk." For tattooists, who form one of the fastest-growing self-regulated creative professional bodies in the world, what Maxime has built offers an inspiring blueprint for the burgeoning relevance of tattoo culture in the wider cultural context.

"You need a lot of drive in London to counterbalance the inertia."

Corporations are increasingly drawn to the Sang Bleu vision and Maxime has been collaborating with brands such as Nike, Hublot, Balenciaga, Alexander McQueen, Damir Doma and Boris Bidjan Saberi. "We undertake these collaborations because of affinity, not necessity. It's our independence and uncompromising nature that defines us and that attracts clients to us." Sang Blue's understanding of not only a particular subculture and demographic but also of fine art attracts a particular type of client. "They are our new political entities and creativity is slowly being more and more privately funded. The companies we work with understand this."

How to get stuff done in London:
London is a really tough place for entrepreneurship. It's still a class society and it's rigid. You need a lot of drive in London to counterbalance the inertia.

What makes a Londoner?
What connects us all is a love for London. We came here for all it has to offer, and if you're from here, you freak out when you leave.

London in a nutshell:
It's one of the only places I know where the client is not king.

Stefanie Posavec

Helping us to understand ourselves better through data

"Data isn't scary. We need to understand what data is, as it forms the building blocks to how we understand the world."

As a data designer, Stefanie has created books, album covers, jewellery, murals, app interfaces, information graphics and a huge collection of art using data as the principle source of input. In the same way that artists use photography, drawing, collage, the grid system or golden mean as a guide for their work, so Stefanie uses data.

"There's a big division between the entirety of the creative industry and data visualisation, because data comes with statistics, science and numbers and that's intimidating to many. But data, which is essentially a pattern of numbers and a rhythm that you can pull from any object in the world, can be used to structure any aesthetic output. People design books using a grid based on human proportions, or use stories to create a painting, but why not make a textile design based on data from weather patterns?"

After studying Graphic Design at Colorado State University near her hometown of Denver, Stefanie moved to London in 2003, where she enrolled in a Communication Design degree at Central Saint Martin's. "My mum came to visit me and told me she'd buy me one art book—they were so expensive at the time. I chose Meada@Media by John Meada. That became a huge influence on me. Meanwhile, I started noticing how everyone was making maps of anything and everything they loved. Both of these things informed where I was heading next."

As her end-of-year project, she visualised Jack Kerouac's On the Road by analysing the grammatical structure of the book and breaking it down into concepts, such as theme, punctuation and words per sentence, a process she did not refer to as data visualisation at the time, but mapping. She called it 'Writing Without Words'. There was no digital copy of the book, so Stefanie did everything manually, going through the physical book line by line. "I still do most of my work by hand today. I love the laborious side of data because it allows me to really get to know the material."

The project drew a lot of attention and in the summer of 2008, it was displayed in the On the Map exhibition in the Millennium Gallery, Sheffield. "People kept asking me about the key insights I had derived from this book, like I was some sort of data scientist. But I just wanted to immortalise a book that I loved and highlight its hidden structures and complexities." In 2009, David McCandless published his book Information Is Beautiful, which included an infographic he commissioned from Stefanie. In the same period, Stefanie started to become a regular on the speaker circuit. But her first real job after university was as a graphic designer and book designer at Penguin Random House, which was followed by commissions for the band OK Go—she designed the cover of their Of the Blue Colour of the Sky album—and Stephen Fry's The Fry Chronicles app, for which she designed the interface. In 2013, the V&A invited her to join a group of 19 other designers to illustrate a short story written by Hari Kunzru, for the exhibition Memory Palace.

This led to numerous art commissions and, eventually, to a seven-week art residency at

Facebook's Menlo Park campus. The ask? To make a piece of art using any data she wanted. She reached out to couples working at Facebook, mapped their online interactions and created dance step diagrams that allowed other people to essentially dance their journey of knowing each other across timelines. "It made me wonder what other different experiences I could use to visualise data, like movement or touch."

"Tracking your life is important. Collating data about it means your life is important enough to you to record."

The topic was explored extensively in Stefanie's 2016 book *Dear Data*, which she co-created with designer Giorgia Lupi. The two met in 2013 at Eyeo, the annual festival of art, data and creative technology in Minneapolis. They soon realised that they shared a love of hand-crafted, information-based design and wanted to collaborate. With Giorgia living in New York and Stefanie in London, they came up with a project that seemed feasible: to write weekly postcards to each other in order to explore whether it was possible to know someone through data alone.

Over the course of a year, they sent a total of 104 postcards covering topics such as how much swearing they had done, who they had met, what compliments they had received, what they had eaten, smelled, seen or been distracted by. On the front of the 7x5 postcards, they hand-drew the visualised data using layers upon layers of shapes and symbols, explained by a highly detailed key. The project became a book in 2016, which The Washington Post described as "a human portrait with data. What emerges from this information overload is a fascinating catalogue of the complexity of daily living." For Stefanie, the project was a way of making data more accessible, engaging and memorable. "I'm interested in how we can communicate the fact we all leave daily data trails and make that data more interesting. And instead of having your mobile phone track you, having to track it yourself makes it more meaningful because tracking your life is important. Collating data about it means your life is important enough to you to record."

Dear Data has been a part of the permanent collection of New York's Museum of Modern Art since late 2016. It has inspired people all over the world to start their own postcard series and some voices in education have been campaigning to make the project part of the national curriculum. It also sparked the creation of a second collaboration between Stefanie and Giorgia in 2018, a book entitled *Observe, Collect, Draw! A Visual Journal*. A mini-course in information design, it serves as a guide to help you quantify your feelings, habits and possessions and learn more about yourself through creative exercises. "People use the book as a way to be creative without needing the ability to draw. It teaches you more about yourself. It helps you to get closer to your life."

In a time where data has become such a scary and dirty word, associated with theft, manipulation, privacy breaches and Big Brother, Stefanie has managed to give people a sense of ownership over their data—to associate data with beauty, personal growth and artistic potential.

How to get stuff done in London:
You need to be able to approach people. Once you learn to do that, you'll be fine.

What makes a Londoner?
Anyone can be a Londoner because everyone is from somewhere else anyway. Once you're here for about three months, you're a Londoner in my eyes.

London in a nutshell:
London is full of mystery.

Jeremy Chan and Iré Hassan-Odukale

Ikoyi

Exposing Londoners to a unique new cuisine

In defiance of many conventions of the London hospitality scene, childhood friends Jeremy Chan and Iré Hassan-Odukale created a Michelin-starred restaurant in central London with a truly unique cuisine that draws as much inspiration from architecture, robotics and childhood memories as it does from Nigerian ingredients and classic British fare. "Our menu is a combination of Google, creativity and love," says chef Jeremy. "I take a hyperanalytical approach to ingredients and then I react aesthetically to them."

"We love the idea of a fine dining restaurant that assaults you."

Ikoyi's cuisine uses extremely high-quality ingredients and sophisticated techniques and can only really be described as utterly tasty and unidentifiable. The inspiration comes from West Africa, but that is just a starting point for a comprehensive aesthetic and gastronomic experience. "We create our own cuisine here. Everything is abstract and an artistic interpretation of ingredients," Jeremy continues. "My rules are: it has to be hyperdelicious, with superimpactful flavour and great quality ingredients. I want the menu to be alienating, totally original and essentially untraceable. Essentially, we make comfort food, just made with products you haven't seen combined before. And we spice things quite aggressively—we love the idea of a fine dining restaurant that assaults you."

An example of an Ikoyi signature dish is its fried plantain dusted in raspberry salt and served with an emulsion of oil infused with smoked scotch bonnets and shallots. A simple and beautiful-looking two-bite dish, it hides as many as 15 ingredients and looks like it belongs on Mars. Another favourite is their crab Jollof rice, which uses burnt vegetables and a stock made with seaweed, anchovies and mushrooms as a vehicle for cooking the rice, topped with a crabmeat salad and brown-crab custard that are smoked à la minute. "Although Jollof rice is an emblem of West African cooking, the logic of our dish is deliciousness, not tradition. We really should be calling it 'smoked crab rice'", explains Jeremy. Iré adds: "You could call us a modern British restaurant, really. We're definitely not a Nigerian restaurant: we're not in Nigeria and we couldn't possibly, or would want to, create authentic Nigerian dishes without access to the region's native ingredients."

Although West African food is a big part of the London food scene, especially in areas like Dalston and Peckham with their many food markets and local food joints, this sort of elevation of its cuisine to a gastronomic level has not been done before in London. "The existing venues exist for the diaspora. You don't get other people trying them," says Iré.

It was Iré who initially approached Jeremy—who had recently been cooking at Heston Blumenthal's Dinner—with the idea of opening a Nigerian restaurant. Jeremy quickly came up with a gimmicky menu for a concept restaurant that would appeal to a mass market. "But we looked at it and realised it lacked all integrity and it wasn't what we wanted. Instead, I started researching Nigerian products and ingredients and we realised that, instead, we wanted a creative eatery with the best food in the world and to design the most beautiful experience people can have."

> "For two random non-white guys to rock up and be like 'We're going to cook amazing food, trust us', that didn't go down so well."

For the two young men, with their backgrounds in finance, their respectively Nigerian and Chinese-Canadian heritages, and without any experience of cooking West African food or running a restaurant, securing a Central London property was a brutal experience. "Every single spot in London is represented by a property agent who doesn't want to deal with people who aren't serious. So for two random non-white guys to rock up and be like 'We're going to cook amazing food, trust us', that didn't go down so well", Jeremy recalls. Iré says: "People loved the fairy tale of us being connected to Africa somehow, wanting to fetishise the African experience and make it digestible for the Western audience, but that's just not what it was. Most restaurants serve the need of a market, but ours isn't necessarily clearly identifiable as a product for a definable market."

The duo spent months courting property agents with tasting meals, hoping they would put them in front of a landlord. "We'd have to cook for them and spent weeks creating a tasting menu, commissioned pottery and chose pairing wines, only to never hear back," Iré remarks. It took a year, but they eventually secured a spot just off Piccadilly. "We wanted to be accessible to everyone and not be associated with any particular vibe. This is a cultural no man's land and attracts a very international crowd." Jeremy points out that "the East London restaurant scene has great places but lacks diversity. They all serve the same food, in the same decors, by the same people. It would have been very hard trying to do what we do there."

In their own words, Ikoyi projects an anti-British sentiment. "We want to make a statement of warmth. The restaurant is a vision of what hospitality means to us. We treat everyone the same," says Iré. Their goal is to create the best experience for guests, attending to their every need by being hyperattentive but not obtrusive. This concept extends to there being no menu. Instead, the guests are asked if they want four or seven courses, and are offered alternatives for any dietary requirements. There is none of the stress or fuss that having to choose can cause. The menu is naturally gluten-free and even the walnut ice cream, infused with peppercorn oil and served on a bed of caramelised white chocolate, is dairy-free.

Despite the fact that Iré and Jeremy are constantly being asked about their future plans, they are not planning on opening another Ikoyi location any time soon. Jeremy explains: "Central London is so wealthy and saturated with powerful landlords that your restaurant has to fit within a certain business model to survive: expansion. But if you spread yourself too thinly, you lose integrity. We want to have patience and do something of the highest quality we can achieve. And we still think we have a way to go to make Ikoyi the very best it can possibly be."

How to get stuff done in London:

Jeremy: You have to be extreme about everything, be persistent and never compromise.

What makes a Londoner?

Iré: Someone who doesn't have time for anyone. If you want to stay in London, you have to work so hard that you don't have time for much else.

London in a nutshell:

Iré: It's a place you need to be able to leave once in a while if you want to remain sane.

Jeremy: It's grey and busy and I generally wouldn't recommend it to anyone. But the big advantage of the city is that it is very acceptant of creativity.

Morag Myerscough

Studio Myerscough, Supergrouplondon

Bringing colour and community to London through design

"I make work that belongs to people and where people belong; work that lives in the public domain and that builds community."

Morag Myerscough's signature colourful, type-heavy design can be found all over the city and beyond, creating temporary and permanent spaces for exploration and interaction—and they bring colour to an otherwise rather grey city. "I'm a real Londoner and have lived here all my life. The work I create is a direct response to London's urban environment. I just love the juxtaposition of brutalism and colour."

Morag inherited her love of colour from her mother, who was a textile artist. "She used to dye her textiles with things like elderberries and let me help and experiment with colour. When I was studying, everyone was obsessed with yellow, red and black and I thought to myself that there had to be other colours to work with." She certainly found them. Her work is instantly recognisable for its oranges, pinks, blues, greens and neons. "It's not always easy to sell people on colour. Brits feel that colour isn't as sophisticated as more monochrome choices. Then when you go to India, for example, people feel that colour belongs to the lower classes. But I think colour is joy and everyone needs joy in their life."

Joy was exactly what she brought to the city in 2017, in a collaboration with Luke Morgan around the Barbican Centre and in the Smithfield Rotunda Garden for the London Design Festival. *Joy & Peace* was a temporary installation in two parts and a response to the bleakness that Londoners often face. "It's easy to get bogged down with the recent spells of violence, terrorism and knife attacks. I want to bring a burst of positivity to the city."

Joy was also a theme in her work with Sheffields' Children's Hospital, for which she designed 46 en-suite bedrooms and six multi-occupancy suites for a new wing of the hospital, with the aim of making the hospital feel more homely. She made sure the designs worked for different age groups and created a space that parents would feel happy in, too. Some of the rooms needed a paler colour palette for children with

"The work I created is a direct response to London's urban environment."

autism or an intolerance to bright colours. The hospital's strict clinical regulations meant Morag made everything in plastic laminate. To achieve the desired, friendly wood effect, she scanned wood grain and added patterns to it digitally, after which it was printed onto paper and laminated.

Morag creates a lot of her designs with the help of the community through running workshops with schools or community groups. One such group was Dalston's Art Kickers, who asked for her help in designing a stage at the back of Dalston's Curve Garden. She ran a patterns workshop with locals that she then incorporated into her final designs. "Pattern workshops are a good method because they aren't reliant on language. Anyone can get stuck in. It's a way to involve the community in a project. And it worked with the stage: now it just belongs to the local community. During Halloween they made it into a huge pumpkin display. I just love that it lives on, constantly changes and is a space that makes people feel that they belong to it."

Belonging is an important part of everything Morag does, and is also the name of a piece she created on commission for the Brighton Festival and Ditchling Museum of Art + Craft in 2018. It celebrated 1960s Los Angeles artist Corita Kent whose work tackled social issues, such as poverty and racism, in a style reminiscent of demonstration aesthetics. *Belonging* consisted of a takeover of the museum's Wunderkammer as well as a mobile bandstand that travelled to eight locations around the country. "One of which was a council estate. It drew hordes of people because it was

outside and was another sign that design really has the power to bring people together."

Her work on the café and bar of architect David Adjaye's Bernie Grant Arts Centre brings the creatives that the centre attracts closer to its visitors by taking their working processes right into the heart of the building. For many of them, their work is only visible occasionally, during exhibitions or seasonal shows. Morag created spaces for artists to add their own additional layers and textures as part of a planned commissioning programme spanning a couple of years. "I want to bring out the potential of what was already there and celebrate it with the people running and visiting the centre."

For a designer who has worked so prolifically, her journey has not always been an easy one. "When I studied at the Royal College, I was continually told that I would never find a job." She set up Studio Myerscough in 1993 with the aim of it being a multidisciplinary studio, initially producing numerous exhibition designs. Almost a decade later, she opened Her House, a gallery for artists who could not find space elsewhere and a shop that allowed her to sell her designs. In 2010, she founded Supergrouplondon with Luke Morgan, which collaborates with artists and architects.

Her contribution to British design won her a commission from the Design Museum to design its first permanent exhibition, *Designer Maker User*. The exhibition examines the development of modern design through the lens of these three actors and includes around 1,000 items across different disciplines, from digital and graphic art to fashion, architecture and engineering. "The Design Museum was transitioning and I went through that transition with them." Morag beat a lot of other well-established names in the industry to win the tender. "The Design Museum's architectural designer, John Pawson, is famed for being quite minimalist and so he and I had quite a different aesthetic. I think I was chosen for that reason—there's strength in difference. It felt like a project where I could bring together my many decades of experience. I feel that I approach a lot of my work from instinct, but that instinct is formed by years of experience."

Morag's work takes her to many countries around the world, and she undertakes about one London project a year. "The London audience is the hardest audience. They've travelled the world, have seen it all and are so in tune with everything that's happening. You might be huge in Scotland but then you move down to London and you're a tiny fish in a huge pond. There's so much competition here and also so much potential. The 2012 Olympics woke London up and changed the local councils' perception of art structures in public spaces, and that's so exciting to me." Despite the fact that she thinks about leaving the city from time to time, she says she probably never will. "Every time I think about it, I panic."

She feels empowered by mayor Sadiq Khan's commitment to championing design in the city. His *Manifesto for all Londoners* reads: "As Londoners, we are lucky enough to have access to some of the world's best public spaces and world-famous streets and squares, but too many are blighted with poor design, clutter, congestion and pollution. I will work with communities, boroughs and the private sector to improve our public spaces and create more liveable streets and spaces."

Morag adds: "That's a mission that's close to my heart. I want to bring people together around joyful spaces and then leave it to the community to own, change and inhabit, to create a sense of belonging, which Londoners so very much need."

"I approach a lot of my work from instinct, but instinct is formed by years of experience."

How to get stuff done in London:
You have to be proactive and open to collaboration. And if you have a more quiet nature, you need to get an agent to do the pushing for you.

What makes a Londoner?
A liberal mindset, bravery and acceptant nature. You experience so many complex situations here on a daily basis that teach you just to get on with it.

London in a nutshell:
It's not a city for wilting violets.

Rosaline Shahnavaz

Steering a new, intimate aesthetic in photography

Bridging portraiture and fashion photography seamlessly, Rosaline Shahnavaz's work is instantly recognisable for its intimate, feminine, raw, colourful and energetic portrayal of—mostly— women. Throughout her work, she brings out the innocence, playfulness and strength in her subjects that have graced the pages of *AnOther*, *Wonderland*, *i-D* and *Dazed*, and captured the attention of brands such as Urban Outfitters, Topshop, American Apparel, Pull & Bear, FarFetch, Burberry, ASOS, Coca-Cola, the National Theatre and Loewe. "I've managed to work with brands who look for that natural vibe in my work. It's every photographer's dream to have a client call you and say, 'We want exactly the style of your personal work. Just put the models in our clothes.'" The fact that her personal and editorial work is almost indistinguishable from her commissioned work seems to point to new possibilities for fashion photography, bringing to it a greater depth, relatability and, essentially, sincerity.

Rosaline predominantly shoots on film, which she learned as a teenager when her father gave her his camera. She took it to school where one of her teachers taught her how to use it and how to work in a dark room. "I spent all my lunchtimes in there, just losing track of time." So despite her talent for maths, Rosaline decided to do a foundation course at Central Saint Martin's and then a degree in Photography at the London College of Communication.

Her final project at the LCC focused on her cousin Sahar. *Far Near Distance* follows the girl around her home in Northern Tehran, capturing her in unusually intimate shots, her head bare of the hijab she's usually seen in. The project set the scene for Rosaline's highly celebrated 2017 book FERN, named after her close friend and muse whom she met on an American Apparel shoot. "I cast her for a campaign I was shooting and we had incredible chemistry from the get-go. I couldn't stop photographing her after that." FERN is a collection of extremely intimate photographs shot over the course of a year of hanging out, unforced and seemingly without much of an agenda. "I know I wanted to make the images into a book eventually but hadn't thought about how until Dark Horse Wines approached me. They funded the printing and launch events in London and New York."

Her project with Sahar is not the only time Rosaline has worked with family. Many of her shoots have been styled by her older sister Nazanin, including one with 86-year-old Frances for Refinery29's *Life Begins At* project, which celebrates inspiring women over 50. Their approach to styling and photographing Frances was refreshing: with her grey hair down, dressed in big patterns, high heels, denim and slogan T-shirts.

"I'm a feminist but I'm not a feminist photographer."

There's a certain New Age, rock 'n' roll quality to Rosaline's work, which portrays her subjects as empowered and free beings. Her intimate, uncompromising and respectful gaze has led to her being referenced as a feminist photographer, a label she is not very comfortable with. "I'm a feminist but I'm not a feminist photographer. A lot of models are very young and feel more comfortable with a female photographer, though. Women have a special relationship—there's an unspoken sisterhood."

> Sarah Hesz 36
> Katie Massie-Taylor 35
> MUSH

IT WAS A CHANCE meeting in a rainy London park one November three years ago that led to Katie Massie-Taylor, who has two children, and Sarah Hesz, a mother of three, inventing Mush, the app that's been dubbed 'Tinder for mums'.

'It can be hard for new mothers,' says Massie-Taylor. 'Neither of us wanted to spend the whole day with no one to talk to. We could see women who were lonely and finding things difficult, and having a friend makes it all so much easier.'

She continues, 'We knew that things had to change, so we thought, why – in a world of apps and platforms to connect people – is there no app for new mothers?'

The resulting app – which launched in 2016 and has now secured more than £2 million in funding – allows mothers to search for friends in their local area, with additional filters for interests and children's ages.

The pair put Mush's success down to what they call the 'Mush Army', mum-to-mum communities, with posters, Love Hearts sweets and bubbles for the children. The strategy worked: more than half a million downloads have been forged as a result.

Now, the pair run a team of 30 and have expanded Mush to include a book and new features they hope to take international.

'There's nothing more important, particularly for mothers, than connecting,' says Massie-Taylor. 'We're making it our mission to make them feel happy, supported, connected and confident.'
letsmush.com

> Bea Warner 28
> EXAACTLY

GROWING UP in the countryside and realising how difficult it was for couriers to deliver parcels to her rural address was all the inspiration Bea Warner needed to set about revolutionising the delivery systems we use.

'They are based on outdated models,' says Warner. 'We're living in a time when we expect to be able to have anything delivered to our homes, and if you speak to any driver, the biggest difficulty is the last mile, finding the address. It costs more than half of the cost of the whole delivery.'

This gave her the idea for her addressing-system business, Exaactly, which allows customers to give retailers and couriers a pinpoint location, photographs, instructions and more to ensure a successful delivery – all by email.

After working part-time on building her company for eight months, Warner began working there full-time in early 2017.

Having initially focused on networking and building a system of advisers and investors, Exaactly really began flying when it was accepted on to the John Lewis start-up initiative in summer 2017. This 12-week programme, which provides office space and product validation, raised the business's profile and allowed Exaactly to create a pilot app that was used in a first round of testing.

Now Exaactly, which is based in Battersea and has four employees, is trialling its system with drivers from Waitrose and Yodel.

In the future, Warner hopes to launch additional delivery features such as consolidating multiple deliveries into one, changing a delivery address after check-out and having a package delivered to a personal pin-point location rather than an address.

'It's exciting,' says Warner. 'I think there's a whole system to shake up, and that's our vision – to connect the courier, the consumer and the retailer into one loop.'
exaactly.com

> 'It's exciting... there's a whole system to shake up'

Rise and Shine
The irresistible charm of Holly Willoughby

Weekend 14.04.18

The Guardian

Hug it out: how we greet now
Toxic air: what happened at Stirling
Affairs: would you want to know?

Weekend
11.08.18

All things bald and beautiful
What Chewing Gum's Michaela Coel did next

The gal-dem takeover
The meaning of Beyoncé
Truth about DNA ancestry
My hunt for a woke man
Lisa Tork la's beauty secrets
Young activists
Dane Abbott's secret snacks
Travel tips for women of colour
Summer denim

The Guardian

National Theatre

Travelex £15 Season

JULIE
by Polly Stenham
after Strindberg

"Shooting people is about their brand, not mine."

Although she has photographed men—her boyfriend and his friends appear in a lot of her early work—she describes how she sees many of her current projects as "explorations of the female identity and thus, myself. It is easy to share an experience with a woman and just document the in-between moments. In those moments, the camera is almost secondary. Shooting people is about their brand, not mine."

Rosaline is known for the relaxed and safe atmosphere she brings to a shoot. "I always focus on the connection with my subject, not so much on who that person is in the eyes of others. Whether I'm shooting a famous model such as Adwoa Aboah or a young, unknown model, what I feel about that person is what I focus on."

With a reported 2% of all photographers doing commercial work being women and only 5% of the pictures used by leading publishers being taken by women, there is a distinct lack of a female lens in today's media. "And I'm a female with female values and those values seem to be resonating today."

How to get stuff done in London:
Hard work and immersion in the abundance the city has to offer. There's no excuse here not to see and experience everything.

What makes a Londoner?
Arguing over what part of London is the best, and complaining when you have to go to a part of London you're not as familiar with.

London in a nutshell:
It's home.

Mark Maciver

Slidercuts

Shaping hair and culture from the barber shop

"In the black community, the barber shop is one of the most important places, like the pub is for the white-collar worker."

In a campaign Nike launched in February 2018, entitled *Nothing Beats a Londoner*, 258 members of the public showcase their sporting passions interspersed with cameos from well-known Londoners, including Skepta, Mo Farah, Harry Kane and Dina Asher-Smith. Comedian Michael Dapaah visits the barber in one scene, and that barber is Mark Maciver, one of London's best known and most loved.

Mark has been cutting hair since he was 13; first his own, then his friends' and family's, and later the community's. These days, he is also responsible for some of the trendiest haircuts out there, as rocked by his celebrity clients: rapper Tinie Tempah's fade and curly top; boxer Anthony Joshua and musician Stormzy with their natural shape-ups; and TV personality Reggie Yates's, with his skin fade and flattened curls on top.

But in his own words, the barbershop is a democratic place. "Everyone comes here, from a street sweeper to a successful lawyer, and I cut them all. No matter how successful you are, you still need a haircut." They might come for a shape-up, but they get more than that. "In the black community, the barbershop is one of the most important places, like the pub is for the white-collar worker. It's the one place where young black men connect and are inspired by older, successful men who aren't drug dealers or criminals, but not necessarily athletes or musicians either."

Mark recalls his journey into the world of hair: "I was always looking at hair—I was obsessed with Carlton's hair in *The Fresh Prince of Bel-Air*—and drawing shapes in the back of my school books. But to save money, my mother used to cut my hair as low as possible, like most Nigerian mums do. So I started shaping my own, failing, learning and improving with every haircut. Soon I was cutting my hair every three days or so, and then my cousin's, my brother's and my friends'."

He became known as the go-to guy for a sharp cut and didn't even charge people for the first few years. When he was offered a chair in a newly opened barbershop, D&L's, he was too scared to accept it. "I was terrified to cut 'a real client'. I realised you could really mess someone up." But the shop persisted and eventually convinced him to give it a try.

Mark spent all his time at the shop, cutting hair before and after college, where he was studying performing arts. Soon, he became D&L's co-manager and looked after the business side of things. Instead of pursuing university, he was taking voice lessons and dance classes, and trained as a qualified personal trainer. "I was thinking about taking a business course, too, but realised that through D&L's, I already knew how to run a business."

At age 25, Mark knew that if he wanted to focus fully on being a barber, he needed a brand. He got himself a name and a website. "My nickname has always been 'Slider', a name I gave myself MCing in my early teens. There wasn't some clever reason for it; I just wanted something that rhymes with a lot of words." Initially he was going to go with 'Slider the Barber' but his wife and brother suggested 'Slidercuts'. "I was the first individual black barber with their own website in 2010. Then, when Instagram hit, I jumped on that, teaching myself how to use every feature, literally googling 'How to use Instagram'."

Eight years on, Mark has a huge following. "I believe that's due to the fact I create content for the viewer, not for myself. That's a mistake a lot of people make. I try and bring the viewer into my stories, explain what I'm doing and I use

a lot of eye contact. I knew from the beginning that Instagram would be key to bringing in business and it has." He has even worked with the platform to teach others to use it effectively and collaborated with Facebook on a campaign, entitled *Let's Get to Work*, to encourage people to use the technology for business purposes.

In 2014, Mark decided to set up on his own. "I had stalled that decision for ages out of some false sense of loyalty to D&L's and then realised how silly that was." But it was not until the autumn of 2018 that Slidercuts finally opened on Hackney Road. "I was so specific with what location I wanted: there had to be parking, the area needed to have a big African, Caribbean and Asian community and there couldn't be an excess of barber shops."

Now that he has his own place, Mark is turning his attention to helping others to achieve similar success. When he initially moved to Dalston in 2011, he did so partly for the abundance of Nigerian and Caribbean eateries in the area. But there has been a sharp decline: every month, he sees another place close down. "Everyone is telling me that it's down to gentrification. But I know there are other reasons. When I started looking into it, I found that all the places that haven't survived, hadn't been doing some very basic things: put deals on, advertise in the local paper, use social media." He realised that he had the power to help his community not only to look their best, but also thrive in business and put their mark on culture.

That was the start of his *Shaping Up Culture* initiative. In a series of master classes aimed at young people with a background similar to his, he focuses on the practicalities of starting and maintaining a business, branding and social media. He wants to change people's mindsets and behaviour. "In my community, there's this organic mindset, a belief that good things should come to you naturally. But you don't become successful overnight; it takes time and hard work. I want to teach people to *make* themselves valuable to others." He is now planning on writing a book based on the content he created.

"The barber is a respected figure in society, much like an uncle, and you can use that power for good."

Mark is very aware of his responsibility to keep young men out of trouble. "The barber is a respected figure in society, much like an uncle, and you can use that power for good." He recalls how he used to cut the hair of rival gang members, gently persuading them that they should bury the hatchet—and eventually succeeding. "Often gangs don't even know where their beef started. The animosity has simply become a habit." He takes his role as a moral compass seriously. "I don't hire anyone who is remotely associated with gangs. I don't want any swearing here, I don't play sexually explicit lyrics and I don't have videos playing of girls twerking. We can't be teaching young men to treat people respectfully and then not follow through on that in the shop."

In 2018, Mark won the title of Barber Entrepreneur of the Year at the Black Beauty and Fashion Awards, a Black British Business Award, and the Be Mogul Award, which celebrates the contribution of black British business owners and entrepreneurs. "They allow me to continue what I'm doing, which is combining all the passions I had as a young man: use my love for performance art in my social media and public speaking gigs, flex my social worker muscles and provide a place of refuge, and shape up culture, one hairline at a time."

How to get stuff done in London:
You need time, effort, consistency and currency: you can't just put time and effort into something at the start—you need to keep at it. No one cares if you're good once—you need to be consistently excellent. And even if you don't have money, you always have some kind of currency to trade, be it your knowledge, skill or time.

What makes a Londoner?
It's a mindset. Londoners are go-getters, they're always on the move and they strive for the best.

London in a nutshell:
It's fast-paced and that makes the city hard to adapt to.

Vicky Jones

Championing new writing in theatre and television

RUN

by

Vicky Jones

Nov 9th 2018

EP
DryWrite Productions
Different Animal

EOne Television
9465 Wilshire Blvd
Ste. 500
Beverly Hills
CA 90212

(310) 407-0960

Vicky Jones is behind some of the freshest, most honest, surprising and raw television and theatre of recent years. She has given voice to female characters that are outspoken, intelligent, educated, sexually liberated and, until recently, conspicuously absent from our screens and stages.

Her long-time collaborator and best friend, actor, writer and producer Phoebe Waller-Bridge, has captivated audiences with the hugely popular TV show *Fleabag* since 2016. Vicky cast her in a play she was directing after Phoebe walked up to her in a pub one night in 2007 and handed her her CV. "She urged me, albeit very politely, to give her a shot." Vicky did, and when she was subsequently fired as director, Phoebe quit in solidarity. "It was an incredibly traumatising experience but it meant we connected over a mutual desire to have artistic control, champion new writing and surprise people." A year later, the duo opened their writing company DryWrite with precisely that goal in mind.

Vicky and Phoebe started organising one-off writers' nights called *DryWrite Presents*, where they would give writers a particular challenge: make the audience fall in love with a certain character, make them think objectively about a situation, or get them to heckle. During one such event, called *DryWrite Presents: Guilty?*, seven actors played criminals who justified their gruesome crimes and it was up to the audience to condemn or acquit the suspect by physically standing on either side of the stage. "We were excited about new writing but we couldn't pay any of the writers so we skewed it into being a writers' laboratory, where they were given a clear objective. Often, writing never sees the light of day, but with us, the writers knew what they were writing for, and that their piece would definitely be performed, so we managed to get some truly amazing actors and writers involved."

With easy access to all this extraordinary talent, a desire grew to produce a long-form play. DryWrite commissioned Jack Thorne to write one set entirely in a bathroom. *Mydidae*, which Vicky directed and Phoebe acted in, explored the darker side of a couple's relationship on the

"Women are harder to write because we hide more of ourselves and that's because we are always looked at, judged, desired and objectified."

anniversary of a devastating event. Meanwhile, Phoebe wrote an act for one of Deborah Frances White's (of the hugely popular podcast *The Guilty Feminist*) stand-up comedy nights. That act became the first ten minutes of the play *Fleabag*, which tells the story of a 30-year-old woman trying to navigate the pitfalls of life in London, with Phoebe in the eponymous role and Vicky back in the director's chair. *Fleabag* won the Edinburgh Fringe First Award, was nominated for a Laurence Olivier Award and in many ways changed both women's lives. "Phoebe didn't start writing it until three weeks before the festival and wrote the last bits on the train over there. But it worked. The Edinburgh audience will tell you what they think, and they loved it. It was exhilarating for me to witness everyone else seeing Phoebe as I'd always seen her", Vicky recalls. When *Fleabag* was adapted into a series for BBC Three and Amazon Studios, Vicky signed on as script editor. "I will never do that again. By then, I had decided I just wanted to be a writer. And when you're a writer, you need to write."

And write she did. In 2014, she penned *The One*, a chilling and gripping comedy-drama about relationships, intimacy, honesty, jealousy, sex and consent. It originally opened at Soho Theatre with Phoebe in the role of Jo. "The part, which talks

"Bringing theatre to the people enriches our society."

about the blurred lines of sexual consent, was based on a personal experience, something that happened to me that I didn't understand at the time." It was revived in 2018 with different actors and received a more nuanced response from the audience. Whereas some of the initial reviews had described the play as deliberately shocking, the conversation around consent had now moved on. "There was such a distinct lack of writing that explored the complexity of what it means to be a woman in the modern world before. I wanted to explore my right to be a feminist but also be many others things. Women are harder to write because we hide more of ourselves and that's because we are always looked at, judged, desired and objectified."

In 2017, Vicky wrote her second play. *Touch*, which Vicky also directed, is a modern-day not-quite-love story in which a 33-year-old woman has a series of sexual escapades in her messy 40-square-foot London apartment, fuelled by Tinder and wine. "I want so much to write about the psyche of women, tell our truths and talk about what women go through. Phoebe and I were part of a tipping point. We created a dialectic for ourselves, our friends and peers. Now there are many more female writers out there and our experiences are a much bigger part of the mainstream conversation."

Vicky wishes more people would try their hand at writing. "More people should try. I can't write prose to save my life but I can write a script. And I feel like more people could, too. It's a great time to work in television because the times are gone where a studio would say 'Oh, we already have a female-led story this year.' But there are still so many stories we haven't seen yet. Too much of what's out there is high-concept stuff. You can still write crime, but have it be character-driven."

That's exactly what the hit show *Killing Eve* does, for which Vicky penned one episode and Phoebe is the showrunner. It premiered on BBC America in April 2018 and on British screens in September. Adapted from the novella series *Codename Villanelle* by Luke Jennings, it follows detective Eve (played by *Grey's Anatomy's* Sandra Oh) on a wild-goose chase to find assassin Villanelle (played by up-and-coming talent Jodie Comer) and subverts the classic crime genre with a good dose of comedy and a unique female lens. In fact, all the male characters are superfluous.

Vicky and Jodie's paths crossed again on the set of Vicky's short film *Bovril Pam*. Marking the centenary of women's suffrage in the UK, it is part of an eight-episode BBC Four series called *Snatches: Moments from Women's Lives* and curated by the Royal Court Theatre's artistic director Vicky Featherstone. The series features actresses aged 18 to 80 talking directly to camera as they recount moments of history that would otherwise have been forgotten.

In late 2018, Vicky shot the pilot of *Run*, which she wrote for HBO. It's a character-driven comedy thriller featuring Merritt Wever (*Godless* and *Nurse Jackie*), Domhnall Gleeson (*Ex Machina* and *Harry Potter*) and Phoebe, who shares an executive producer credit with Vicky. This marks the first time DryWrite has produced a television series. But Vicky will not be making a choice between writing for the screen or the stage any time soon. "I love both: the live aspect of theatre is fascinating, but the permanence, reach and democratic nature of television is unbeatable."

Luckily for Vicky, Londoners are very open to theatre and it is reasonably easy to find an affordable seat, be it on or off the West End, since most theatres offer standing-room tickets and sponsored seats. "It's still too expensive though, but the local theatres are making a big effort to attract new demographics. Bringing theatre to the people enriches our society."

How to get stuff done in London:
You need money, or at least a way of scraping money together, and motivation.

What makes a Londoner?
The necessity of living together in close proximity makes Londoners tolerant, open-hearted and kind.

London in a nutshell:
London has it all: rivers, parks, opportunity, attitude, and affordable things to do at every corner. It offers a home to everyone.

Fred Higginson, Rose Stallard and Kate Higginson

Print Club London

Democratising the making and owning of art

Down a cobblestoned alley in the heart of Dalston, East London—home to some of the city's most creative minds, artists and entrepreneurs—is a colourful, buzzing screen printing studio and co-working space called Print Club, run by husband-and-wife duo Fred and Kate Higginson, and illustrator Rose Stallard. "Our space is welcoming to people who want to get their hands dirty and make a mess, and that's rare in London," says Rose. "We have managed to create a creative space which isn't judgemental and brings together hobbyists and professional artists."

Print Club London supports artists by providing equipment and space, and selling its members' artwork online. The studio also teaches the art of screen printing, offering two workshops a week. "We had great support from artists from the start. Dalston as a location was a great pull, and they loved the idea of us celebrating and popularising a very old art form," Kate says. Their manual *Screen Printing: The Ultimate Studio Guide from Sketchbook to Squeegee* (Thames & Hudson, 2017) provides step-by-step tutorials and workshops by several of the world's best-known screen printers.

Print Club launched in 2007 after Fred moved down to London from Norwich, Norfolk, to set up an artist studio that provided affordable workspace for fine artists. Rose was working as an illustrator at the time and rented one of Fred's spaces. Working mainly with a computer, she felt a need to get her hands dirty again, and predicted that a lot of people felt similarly. "It was a time where so much art was digital. There also weren't a lot of screen printing studios around because they are expensive to manage: the beds and exposure units need a lot of space and you need technicians to help work the equipment. So I felt there was a gap in the market for an affordable screen printing facility," Rose explains.

She proposed the idea of opening one to Fred, and together they amassed the necessary equipment from different parts of London, some of it given to them and some purchased. Six months later, Kate joined them to look after the business side.

"The beauty of screen printing," Kate explains, "is that it lends itself really well to artistic expression. It elevates work, be it photography, collage, clothes or bags. You don't need be an exquisite fine artist to create extraordinary work. It's more about the idea. Andy Warhol wasn't a great craftsman, for example, but he made his ideas come to life beautifully with screen printing." Fred continues: "Street artists love it because they can use their stencils in a screen printing process and create different types of art that are reproducible." Rose adds: "You can learn the basics in just one day, but then the journey only begins. At the start you make mistakes, but sometimes they can look really good—you learn to play with the medium."

In 2008, the team put on the first-ever *Blisters* show—now one of the country's largest poster exhibitions, attracting around 2,000 people to the MC Motors warehouse in Dalston every year for the one-night event. On the first night, they sold each poster at £35, with 35 editions per poster, taking a surprising £30,000 in cash, something they were completely unprepared for. "We were stuffing it in poster rolls and back pockets, scared we'd get robbed because we had advertised everywhere that we were only taking cash," Kate recalls.

"Andy Warhol wasn't a great craftsman but he made his ideas come to life beautifully with screen printing."

To ensure a well-curated and surprising *Blisters* show every year, the Print Club team sends a brief out to the community and reaches out to well-known artists. "We work with a brief because a lot of illustrators and designers are used to working in that way. It has a different theme each year, such as 'Glow in the dark' or 'Music' and it specifies a certain size," says Fred. They like to keep their prints at a universal 50 x 70 cm size so people can pick up an IKEA frame if they want to, despite the fact that the Print Club website offers a framing service. "It's just another way for us to ensure art remains affordable and accessible to people," Kate explains.

The *Blisters* shows are a yearly highlight for many art-loving Londoners. "People love to invest in art, but it's simply outside the budget of many. And for people who are renters, it's risky to invest in expensive art that might be hard to transport or not suit your next house," Fred suggests. The 2018 show featured 50 artists, a mix of knowns and unknowns, each selling 50 signed, limited-edition screen prints for £50. "The idea that you can own art by an established artist for £50 is very exciting to people," Kate comments.

Over the years, *Blisters* has sold commissioned work by the likes of Anthony Burrill, Pure Evil, Kate Moross and Ben Eine, exhibited alongside lesser known artists. Kate adds that "the appeal for artists is that they get to work on a non-commercial brief and get to be part of a collective show. It takes them back to their art school days."

Despite being a place for experimentation and exploration, Print Club is very commercial. As Fred puts it: "We take a sizeable commission, 50%, but we put 10% of that back in promoting the artists online. The average spend of someone buying artwork from us has gone from £60 a few years ago to £230 today. A lot of the artists we work with don't know how to market themselves and without knowing how to sell their work, artists simply can't survive."

One of the exceptions is well-known London artist Dave Buonaguidi, who, as an experienced adman, is one of the studio's bestselling artists.

His work sells for between £20 and £600. "Dave understands what people want," Kate says. After working in advertising for over 30 years and founding two different ad agencies, he took a year out to learn to screen print at Print Club. He is now a celebrated artist, probably most famous for his screen printed maps of various cities featuring big type, and his work is held in the V&A's collection. "Dave reacts well to what the market tells him. When we told him big type was in fashion, he started incorporating it more and more into his work. When people started calling out for him to make maps of cities outside of London, that's what he did and they sold out immediately." The trio also works with corporate clients, producing bespoke bags for Stella McCartney and running live in-store printing projects with Nike.

Print Club has applied its skills, services and network to raise funds for good causes. In the summer of 2018, they put on a fundraising exhibition for Help Refugees, one of the largest humanitarian organisations focused on the plight of the displaced. Artists including Mr Bingo, Lauren Baker, Quentin Jones and The Chapman Brothers each interpreted the iconic 1980s 'Choose Love' slogan by fashion designer Katharine Hamnett to create collages, photographs and screen prints, with all proceeds from the sales going to the charity. Acclaimed British sculptor Anish Kapoor created a special 12-edition, £400-a-piece series of prints for the show, which opened in Somerset House. The exhibition is ongoing, with at least one Print Club member making a 'Choose Love' piece every day.

In a part of town where every week more shops, warehouses and artist spaces are being renovated into high-value flats, Print Club is a much-loved and needed emblem of creative expression.

PRINT CLUB LONDON
LIMITED EDITION SCREENPRINTS

How to get stuff done in London:

Kate: Perseverance. I managed to get the lights of the Gherkin turned on once. We were filming and they went off, so I found the number of a security guy and he switched them on for 10 minutes. London is a place where anything is possible.

Rose: Determination. You have to just believe in what you want to achieve and get on with it.

What makes a Londoner?

Fred: Relishing in the diversity of your fellow Londoners.

Kate: Someone who knows how to navigate the streets like a black cab driver. I know all the shortcuts and could walk from one side of London to the other without a map.

London in a nutshell:

Fred: A multi-layered, organic, spiced onion.

Rose: Beautiful chaos.

This book is MARKED

MARKED is an initiative by Lannoo Publishers.
www.marked-books.com

JOIN THE MARKED COMMUNITY
on @booksbymarked.

Or sign up for our MARKED newsletter with news about new and forthcoming publications on art, interior design, food & travel, photography and fashion as well as exclusive offers and MARKED events on www.marked-books.com.

If you have any questions or comments about the material in this book, please do not hesitate to contact our editorial team: markedteam@lannoo.com.

Every effort has been made to trace copyright holders. If, however, you feel that you have inadvertently been overlooked, please contact the publisher.

© Lannoo Publishers, Tielt, Belgium, 2019
D/2019/45/273 – NUR 450
ISBN: 978 94 014 5431 5
www.lannoo.com

Author:
Senta Slingerland

Editing:
Heidi Steffes

Photography:
James Merrell, except:
p. 29: © Kristin-Lee Moolman
p. 32 *top left*: © Ibrahim Kamara
p. 32 *bottom right*: © Kristin-Lee Moolman
p. 37, 42–45: © Andrea Román
p. 60 *top*: © Ed Gilligan
p. 60 *bottom*: © Lea Anouchinsky
p. 75 *top*: © Secret Cinema / Mike Dawson
p. 75 *bottom*: © Secret Cinema / Camilla Greenwell
p. 76 *top*: © Secret Cinema / Olivia Weetch
p. 76 *bottom*: © Secret Cinema / Mike Massaro
p. 78 *top*: © Secret Cinema / Camilla Greenwell
p. 78 *bottom*: © Secret Cinema / Carlotta Cardana
p. 87 *bottom left*: © MIR_Split
p. 87 *bottom right*: © Luke Hayes
p. 88–89: © Julian Abrams / Asif Khan
p. 91 *top left*: © Luke Hayes
p. 91 *top right*: © Hufton + Crow
p. 91 *bottom*: © Asif Khan
p. 107, 108: © Fernando Laposse
p. 118: © Peter Fingleton
p. 119: © Mike Massaro
p. 142 *top*: © Baker&Borowski
p. 142 *two bottom left images*: © Ali Tollervey
p. 142 *two bottom right images*: © SKIP Gallery
p. 159, 163 *top left, two bottom images*, 165: © Tre Koch
p. 198, 199 *top*: © Gareth Gardner
p. 199 *bottom*: © Jill Tate
p. 210–211: © Rosaline Shahnavaz
p. 226 *top*: © Simon Kane
p. 226 *bottom*: © Helen Maybanks

Graphic design:
Marjolein Delhaas

Amb
Bravery an
Rich in culture, t
Amazing ar
It's impossible to
Not a city for
Acceptant
The city
Changing
Full of
Nostalgia, eccent
A collection
Illuminating
Always
Pure b
The best city
Ho
London j